To my daughter, May

Professional
Cartooning

Professional Cartooning

A Complete Course in Graphic Humor

STAN FRAYDAS

 ROBERT E. KRIEGER PUBLISHING CO. INC.

ACKNOWLEDGMENTS

The author and publishers wish to thank all advertisers and publishers whose ads and illustrations have been included in this volume. Grateful acknowledgment is made to art directors and artists for their cooperation in compiling the art work in the chapters entitled "Cartoon Styles" and "Cartoonists' Markets" as well as to W. J. Byrnes, Julia Del Coro, Burton Cumming, Lou Dorfsman, Frank McConnell, Milton Greenstein, Abram Greiss, Dione Guffey, Elaine Hattum, James Hennessy, Scott Hutchison, Jesse Jacobs, Hazel J. Packard, Bill Reimers, Ole Risom, Lester Rossin, Bob Snibbe, Otto Storch, Willard Tangen, Samuel A. Tower, and Hugh White. Deep appreciation is expressed to Tobias Moss for his help in making the publication of this book possible. Special thanks are given to A. I. Friedman, Alex Gotfryd, John Locke, Cullen Rapp, and Joe Sapinsky for their help in obtaining additional pictorial material. The author gratefully recognizes invaluable contribution of June Schetterer in editing the manuscript.

FOREWORD

Pictures — and cartoons in particular — can often stir us to anger or reduce us to tears. They have sparked revolutions, moved empires, toppled governments. They are part of our Sundays and hold an important place in our newspapers, periodicals and magazines. They are truly a candid reflection of our times.

Cartoons are always with us — on car cards, billboards, posters, on TV and movie screens. They do more than entertain us. They persuade us to buy bread and beans and beer. Children of all ages love them. Executives, engineers, scientists doodle 'em — and thus ideas are born.

Cartoons can be subtle, they can be incisive, they can caricature — yet they can be believable and have extraordinary power. As satire they can cut cruelly and deep. As humor they bring a smile or a chuckle. As political weapons they influence decisions, shape events. Cartoons need no words for they are a universal shorthand understood in an instant. They communicate.

Anyone can draw cartoons, but only professionals do them well. This book will tell you how they do it and reveal many secrets about the art of cartooning. You, too, may some day find your scribbles and doodles raised to a professional level.

The author, Stan Fraydas, is a cartoonist of note, a designer of ability and an excellent instructor at New York University's School of Continuing Education.

Tobias Moss
Director, Center for Graphics, New York University

CONTENTS

INTRODUCTION

By popular definition, a cartoon is a humorous drawing. However, the great variety of cartoons in commercial-art fields makes any attempt to define the word precisely a difficult and bewildering task. There are no formal boundaries to the style of the drawings called "cartoons." They range from almost wholly realistic illustrations to almost wholly abstract designs. "Too cartoony" and "not cartoony enough" are expressions from the vernacular of commercial-art people used frequently in referring to drawings. Moreover, to the dismay of many a cartoonist, his drawing may appear "too cartoony" to one client and "not cartoony enough" to another. In the advertising and publishing fields especially, descriptive semantics should be approached by the artist with a great deal of flexibility and circumspection.

An example may serve to underline the characteristic ambiguity of the language used in these two fields. The decorative art work frequently used to illustrate children's books is called "illustration"; in advertising the same style of art is called "decorative cartoon." An artist may walk out of a publisher's office as a children's book illustrator and become a decorative cartoonist as soon as he walks into an advertising agency.

On the other hand, there are several cartoon fields in which the description of drawings as cartoons and of artists as cartoonists is mandatory regardless of style. This holds true for animated cartoons (movies or TV), gag cartoons, syndicated newspaper strips and panels, comic books, and political and sports cartoons. In all of these the drawings remain "cartoons" whether they are realistic and nonhumorous adventure strips or abstract-design movies.

In view of this flexibility in interpreting the words "cartoon" and "cartoonist," it is advisable for an artist specializing in cartooning to describe the style of his work in detail when he is applying for a job or asking for a business appointment. It is uncertain, in many instances, whether an artist should consider himself a cartoonist, a designer, an illustrator, or a sketchman. A more specific description of an artist's work can often save time that otherwise would be lost on a fruitless appointment.

The words "cartoon" and "cartoonist" are used throughout this book on the assumption that the reader will keep these reservations in mind.

There are many career opportunities for cartoonists in the various fields of commercial arts (see the chapter "Cartoonists' Markets"). Naturally, the large cities offer the lion's share because of their concentration of advertising and publishing. But these commercial-art meccas are also saturated with an illustrious assortment of top talent from all over the country and from all over

the world. In these highly competitive art centers, the struggle for success, or for mere survival, is feverish and never-ending. Before engaging in professional training, prospective cartoonists should feel that they have some skill in drawing, some imagination, some sense of humor, and, above all, some native talent.

Talent is an endowment of certain basic attributes that, together, contribute to one's creativity. One such attribute is the intellectual capacity for independent—thus, creative—thinking; another is the technical capacity for expressing this thinking. Theories abound on whether these two basic attributes are congenital or acquired through training and experience. Presumably, evidence of talent appears as the result of a combination of congenital and acquired faculties. An aspiring cartoonist will need some general and art education, as well as training in drawing. Also, he will have to become a keen and somewhat critical observer of events and of human behavior. He will have to learn not only to observe but to interpret what he observes; and he will have to sharpen his sense of humor while developing a discriminating outlook toward people and their foibles.

There are no miraculous short cuts in learning a profession so complex and exacting as cartooning. This book cannot replace a school's train-ing facilities, or its stimulating environment.

The sessions in schematic cartooning (see the chapter "First Steps in Cartooning") are a part of the author's course at New York University. They should prove helpful to beginners as a practical method of initiation into cartooning.

The chapter "Historical American Costumes" may seem superfluous at first glance, but a quick reference on historical costumes may be helpful as a time-saving device.

The chapter "Fundamentals of Printing" should stimulate cartoonists to study further the methods of printing — the understanding or knowledge of which is of great importance in a multitude of assignments.

The chapter "Lettering" is designed to provide cartoonists with an invaluable chance for expansion of their profession into vast areas of designing and art-directing. Knowledge of lettering may provide cartoonists with opportunities to create and design posters, book jackets, brochures, and other promotional material.

This book is intended to inform the prospective cartoonist about the various aspects of his future profession. It may also help the commercial art student to decide whether he should specialize in cartooning, and, if his decision is affirmative, which branch of the profession would be most promising for his particular talents.

THE CARTOONIST'S CAREER

Two types of career are open to cartoonists who are ready for professional, money-earning work. One is salaried employment; the other is free-lancing. Each presents some advantages and some disadvantages. Steady employment generally offers more security and a regular income; free-lancing, though less secure, offers the possibility of earning more money and of gaining more rapid recognition. However, an artist should not engage in free-lancing without some knowledge of the field and without some professional experience. A beginner should start his career by looking for a steady job.

How to Prepare a Portfolio

Preparing a portfolio—a portable case containing artists' samples—is the first important step toward finding a job. Several types of artist's portfolios are available in different sizes. Since they are used outdoors, they should be waterproof and closable, for protection of their contents against rain and dust. Zippered cases are quite suitable for general use.

Samples of work for presentation (of original drawings in the case of a beginner) should be thoroughly clean and pasted on thin, lightweight mounting boards that are uniform in size, if possible. Several small sample drawings may be mounted on the same board. The boards should fit loosely in the portfolio. If samples are prepared on thin paper, white paste should be used under all four corners of the drawing to hold the paper in place on the board—rubber cement tends to stain thin papers through and through. Boards with pasted samples can be covered with transparent acetate (taped on back of boards) for protection and for better appearance.

The appearance of an artist's samples is very important, for, regardless of their quality as drawings, the way in which they are presented indicates the artist's general concern with cleanliness as well as his sense of aesthetic display —qualities highly regarded in commercial art.

When samples are arranged in the portfolio, the best specimens should be placed in the following order: two on the first pages (to create a good impression at the start), two in the center of the portfolio (to sustain the original impression of excellence), two on the last pages (to leave a good impression at the end). But, whatever the arrangement, only the best available drawings should be selected in preparing the portfolio.

A complete portfolio should contain approximately 15 to 25 pages of art work.

Beginner's Job

A beginner should accept the first artist's job offered to him, no matter how humble. On this first employment, which could consist merely of such functions as cutting boards, mounting art work, giving out art materials, and running errands, the beginner will learn much of what he must know to become a professional artist. Usually, the beginner will be assigned a drawing table of his own. He should consider this table a symbol rather than a promise of art work to be done for the studio. For, on his first job, he may or may not be given an opportunity to work on professional assignments. Whatever the case, a beginner should keep his first job as long as possible, and certainly he should keep it as long as he has no offer of better employment as an artist. A beginner's first job brings many hopes as well as many frustrations and disillusionments, but most successful artists have started their careers in this way. All were once beginners.

Free-lancing

In free-lancing several avenues are available to cartoonists who consider this kind of career most suitable for their abilities, temperament, and circumstances.

These avenues are studios, advertising agencies, independent work, and agents.

STUDIOS

Advertising studios offer free-lance artists several kinds of working arrangements.

Work-space is an arrangement in which space in the studio, a drawing table, equipment, materials, telephone, and other facilities are offered to the artist, either for a nominal monthly payment or in exchange for some art work. Usually, studios offering this type of arrangement expect to provide some work for the free-lance artist. But sometimes the arrangement is just a space-renting maneuver of a small studio struggling for survival.

Price arrangements between free-lancers and studios vary.

The **flat fee** is a simple agreement on price for each item executed by the artist for the studio. The artist sets his own price, or he accepts the studio's price.

Percentage arrangements are more profitable to artists, provided they are made with studios known for their integrity. Fifty or sixty per cent of what the client pays the studio for the job is the artist's share. The price quoted to the client for a job often includes the cost of elements other than the drawing by the free-lancer. The price of a complete job may include charges for lettering, retouching of photographs, preparation of mechanicals, etc. These charges are deducted from the total price, and 50 or 60 per cent of the balance is paid to the artist. In percentage agreements, the studio's account books should be accessible to the artist, but in most instances this procedure is waived in order to preserve an atmosphere of trust between artist and studio.

The **percentage with guarantee** offers the artist a reasonable amount of money paid on a weekly or two-weekly basis. The artist's earnings with the studio in excess of this guarantee are paid to him at regular intervals, or follow agreed-upon terms of settlement. Should the artist earn less than his guarantee, the studio pays him the guaranteed amount and absorbs the loss resulting from the difference.

A **drawing account** is similar to a percentage with guarantee, except that, if the amount drawn regularly by the artist exceeds his percentage earnings, the difference is applied against his future excess earnings instead of being absorbed by the studio.

The **hourly basis** for payment is practiced by some studios offering work space, but this type of arrangement is not advantageous to free-lance artists. A cartoonist might be able to turn out art work worth one or two hundred dollars within a few hours and receive a disproportionately meager fee for it.

ADVERTISING AGENCIES

Small agencies frequently offer work space to free-lancers. Agreements on fees are similar to those made by studios. But, since advertising agencies are frequently required to submit many sketches and layouts that never reach the stage of finished art, the free-lance artist should protect himself by requesting payment for all his sketches as well as for finished art. He may ask to be paid for sketches on an hourly basis, and for finished art on a flat-fee or percentage basis.

OWN STUDIO OR HOME

Many free-lance artists work in their own studios or homes. They do not necessarily do this to save money—in this way of working one man must pay expenses that would otherwise be shared by a number of persons. For example, he often becomes involved in the cost of rent, equipment, art materials, telephone answering service, stationery and promotion mailings, etc.

Only experienced artists with established business connections can afford this method of working. Also, they must organize their activities so as to be able to see their clients, pick up and deliver assignments and keep up with their essential work at the drawing table. They may free-lance directly with advertisers, with studios, or with advertising agencies. The problems of free-lancers' own studios are simplified when several artists get together and share expenses.

ARTISTS' AGENTS

Artists' agents, or representatives, are intermediaries between free-lance artists and clients.

One agent will represent many artists. Therefore, it is particularly important that the art work of someone represented by an agent have a distinctive style, so that it falls into a specific cate-

gory and, therefore, is remembered by the clients to whom it is presented by the agent.

The structure of artists' representation by an agent is as follows: the free-lance artist leaves a number of his samples—originals and reproductions—with the agent. An agreement is concluded in which the territory for representation is defined exactly. The artist should exclude from this territory some of his personal clients, potential clients, and professional friends buying art.

The agent solicits work for the artist, pays for the promotion of the artist's work, picks up and delivers jobs to the client, and takes care of the billing. The agent retains a 25 per cent commission on all work he brings to the artist. Usually, the artist has only one agent, but his agent represents a number of artists.

It often happens that a young artist is helped considerably in his career by his agent's efforts and zeal. But it happens just as often that a young artist's hopes for success are completely frustrated because of overconfidence in his agent's ability to bring it about. Hopeful artists should be warned against relying exclusively on their agents' ability to provide them with a constant flow of assignments. Every artist represented by an agent should reserve for himself some reasonable business area in which to seek work when his agent's efforts prove ineffective.

There are instances in which artists are subjected to unethical treatment by their employers, clients, studios, or agents.

Most of the artists employed in the fields of TV and movie animation, as well as those employed in printing, engraving, and photoprocessing industries, benefit from their trade unions' protection. But free-lance artists, and those employed in the advertising and publishing industries, rely on general laws and on the ethical standards prevailing in their professional fields.

Listed below are some examples of unfair practices to which artists are sometimes subjected:
1. Discharging a salaried artist without reasonable notice and without additional compensation.
2. Obtaining an assignment on the basis of one free-lance artist's samples and then giving the work to another artist.
3. Representing several free-lance artists with competing styles.
4. Retaining a free-lance artist's samples without providing adequate representation.
5. Requesting that a free-lance artist perform speculative work for which there is no compensation if the work is rejected.
6. Encroaching upon the free-lance artist's reserved territory.
7. Disregarding a verbal agreement on the percentage arrangement.
8. Making unfounded promises of work when renting studio space to free-lance artists.
9. Paying normal hourly rates for overtime work, night hours and week-ends included.
10. Submitting proofs of artists' work to clients without the artists' knowledge and authorization.

Well-meaning professional associations in the commercial arts field attempt periodically to establish a minimal code of ethics for artists, art services, and clients.

The text of one of these codes follows:

CODE OF FAIR PRACTICE
As Formulated by the Joint Ethics Committee of the Society of Illustrators, Art Directors Club, and Artists Guild. Relations between artist and art-director
1. Dealings between an artist or his agent and an agency or publication should be conducted only through an authorized art director or art buyer.
2. Orders to an artist or agent should be in writing and should include the price, delivery date and a summarized description of the work. In case of publications, the acceptance of a manuscript by the artist constitutes an order.
3. All changes and additions not due to the fault of the artist or agent should be billed to the purchaser as an additional and separate charge.
4. There should be no charge for revisions made necessary by errors on the part of the artist or his agent.
5. Alterations to artwork should not be made without consulting the artist. Where alterations or revisions are necessary and time permits and where the artist has maintained his usual standard of quality, he should be given the opportunity of making such changes.
6. The artist should notify the buyer of an anticipated delay in delivery. Should the artist fail to keep his contract through unreasonable delay in delivery, or nonconformance with agreed specifications, it should be considered a breach of contract by the artist and should release the buyer from responsibility.
7. Work stopped by a buyer after it has been started should be delivered immediately and

billed on the basis of the time and effort expended and expenses incurred.

8. An artist should not be asked to work on speculation. However, work originating with the artist may be marketed on its merit. Such work remains the property of the artist unless paid for.

9. Art contests except for educational or philanthropic purposes are not approved because of their speculative character.

10. There should be no secret rebates, discounts, gifts or bonuses to buyers by the artist or his agent.

11. If the purchase price of artwork is based specifically upon limited use and later this material is used more extensively than originally planned, the artist is to receive adequate additional remuneration.

12. If comprehensives or other preliminary work are subsequently published as finished art, the price should be increased to the satisfaction of artist and buyer.

13. If preliminary drawings or comprehensives are bought from an artist with the intention or possibility that another artist will be assigned to do the finished work, this should be made clear at the time of placing the order.

14. The right of an artist to place his signature upon artwork is subject to agreement between artist and buyer.

15. There should be no plagiarism of any creative artwork.

16. If an artist is specifically to produce any artwork during unreasonable working hours, fair additional remuneration should be allowed.

Relations between artist and representative.

17. An artist entering into agreement with an agent or studio for exclusive representation should not accept an order from, nor permit his work to be shown by any other agent or studio. Any agreement which is not intended to be exclusive should set forth in writing the exact restrictions agreed upon between the two parties.

18. All illustrative artwork or reproductions submitted as samples to a buyer by artists' agents or art studio representatives should bear the name of the artist or artists responsible for their creation.

19. No agent or studio should continue to show the work of an artist as samples after the termination of their association.

20. After termination of an association between artist and agent, the agent should be entitled to a commission on work already under contract for a period of time not exceeding six months.

21. Original artwork furnished to an agent or submitted to a prospective purchaser shall remain the property of the artist and should be returned to him in good condition.

22. Interpretation of this code shall be in the hands of the Joint Ethics Committee and is subject to changes and additions at the discretion of the parent organizations.

TOOLS AND EQUIPMENT

A room or a place in a room, preferably near a window with northern exposure in order to avoid sun glare, is the first material necessity for a cartoonist beginning his career. The following list represents the rudiments of the equipment with which a cartoonist may start to outfit his studio. Only the simplest, most economical, and indispensable implements are mentioned. The most frequently used sizes are indicated in inches next to some of the items.

DRAWING BOARD. A 20″ × 26″ drawing board can be used on an ordinary table. The board should be tilted forward to ensure vision perpendicular to its surface and to avoid strain in bending over the drawing.

LIGHTING. An ordinary "snake" lamp with a 100-watt bulb may be used. It should be placed on the left side of the table for the right-handed, on the right side for the left-handed. A frosted bulb will make the light softer, and is better for vision.

RULER. A 16″ wooden ruler with double steel edges, for measuring, for ruling lines, and for trimming drawing paper and illustration board.

T-SQUARE. An 18″- or 24″-long, wooden or steel T-square. It is advisable to use a metal edge, clamped on the side of the drawing board, for parallel sliding of the T-square.

TRIANGLE. A transparent 12″ triangle.

DRAWING PENS. It is important for a cartoonist to acquire various types of pen points and to use them experimentally on different types of drawing papers. There are Speedball pen points for uniform-width lines as well as round and square points. Popular sizes for drawing cartoons are #5 and #6. Hunt and Gillott pens are used for thick-and-thin lines. At least two penholders are necessary, one for ordinary pen points, another for barrel-shaped crow-quill points.

BRUSHES. Red-sable water-color brushes are available in sizes from 000 to 14. The most popular sizes are #0, #2, #4, and #6. It is important for the quality of work and also for economy to buy only well-known brands of water-color brushes and to clean them thoroughly with soap and water after each use. Inks, if allowed to dry on the brush, corrode and destroy the sable hair.

PENCILS AND ERASERS. Graphite or "lead" pencils come in various degrees of hardness. Soft pencils are marked "B," hard pencils "H," and medium pencils "HB." The softer the pencil, the thicker the lead. At least two erasers are necessary, one for pencil, another for ink. Plastic "kneaded" erasers for pencil, and hard, white erasers for ink are popular with cartoonists.

TRACING PAPER. Most artists make their preliminary sketches on tracing paper, light or medium weight, which is available in pads. A size frequently used by cartoonists is 14″ × 17″. When the sketch is satisfactory to the artist, he transfers it to the drawing paper or illustration board and then finishes it with ink or water color.

DRAWING PAPERS AND ILLUSTRATION BOARDS. Frequently used drawing papers are also available as illustration boards. Two typical paper surfaces are kid (slightly grained), and plate (smooth). Papers as well as boards come single- and double-thick (one-ply and two-ply). It is safer to use double-thick papers and boards. A practical size for drawing-paper sheets or for illustration boards is 22″ × 30″.

DRAWING INKS. Most of the inks used by cartoonists are waterproof when dry. Inks mix with each other well. Popular sets of eight colors contain bottles of black, orange, yellow, red, violet, blue, green, and brown. China or enameled mixing cups or trays are needed for mixing or diluting colors. If a slower than normal drying speed is desirable, inks should be diluted with a few drops of distilled water. A drop of ammonia water, added to ink in the cup, will accomplish a similar slow-drying result.

OPAQUE WATER COLORS. These water-soluble colors are also called poster colors, tempera colors and gouaches. It is helpful to look at a color chart before deciding which colors to buy. Boxed sets usually contain sixteen colors that will mix into an unlimited number of color combinations.

DRAWING INSTRUMENTS. Two basic items are the compass and the ruling pen. A good, com-

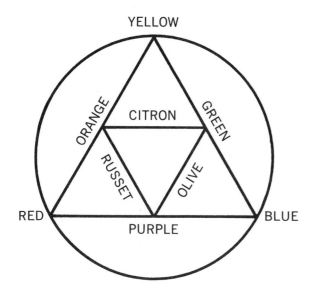

YELLOW

ORANGE CITRON GREEN

RUSSET OLIVE

RED PURPLE BLUE

Schematic drawing showing the mixing principle of using three colors to obtain composite secondary and tertiary colors.

bination compass with pen, pencil, and lengthening attachments is the most practical all-purpose drawing tool. A plain ruling pen is another multiple-purpose instrument.

An inexperienced artist just starting in the field of graphic arts may have a tendency to over-idealize creativity and underestimate the importance of modern tools and comfortable working conditions. He may feel that a "true" artist should be above mechanical gadgetry and that he should rely on his talent alone to become a success. However, in the process of acquiring experience, he will learn how important tools, materials, and equipment can be in his profession. Whatever an artist's specialization may be at the moment, circumstances might arise in which he would need a new tool or some new materials to meet the requirements of an unexpected, nonroutine assignment. New techniques for the preparation of finished art have helped the artist to work faster and with less strain, thus reducing production costs to the client and creating more favorable conditions in the art market.

Changes in graphic techniques and printing methods frequently contribute to changes in commercial-art styles. For example, the posters designed by Toulouse-Lautrec, which were made commercially possible by the development of color lithography, became a cornerstone of modern poster art; the advent of the airbrush set in motion a powerful trend in the use of slick gradation techniques in the graphic arts; quick-drying inks brought in a new "sketching with markers" technique that added speed and, thus, spontaneity to the sketch.

It usually takes some time before a young artist develops an individual and consistent style. One technique may appeal to him or fit his particular skills more than another. His choice of a special pen point, or pencil, or paper surface may determine his future style. An artist I knew successfully changed his style by merely switching from the smooth Bristol board he had been using for his finished art to a rough-surface board. A New York gag cartoonist had good ideas and an attractive rough-sketch technique. The magazine cartoon editors liked his roughs and frequently asked for finished art. But, when they received the finished drawings, they marked them for endless corrections, turned them down, or held them for indefinite "future use." When the cartoonist looked at his finishes, he had to admit that they were disappointingly stiff and tight in comparison with the original pencil sketches. He realized that, in the process of transferring the pencil sketch to tracing paper and from tracing paper to drawing paper, he had lost the spontaneity and editorial appeal of his original rough. He decided to try another finishing technique and acquired a tracing box. By using the original sketch as a direct guide under his drawing paper, he succeeded in achieving with pen and ink an effect similar to his pencil's. The corrections on his finishes stopped, and the artist became a success.

In all parts of the world, from ancient times to the present, the availability of artist's tools and materials has influenced the nature, the applications, and the styles of art.

In addition to the indispensable art implements listed above, graphic artists use a wide range of materials, instruments, and equipment available in art-supply stores. A cross section of these additional items used by cartoonists is listed and illustrated on the following pages.

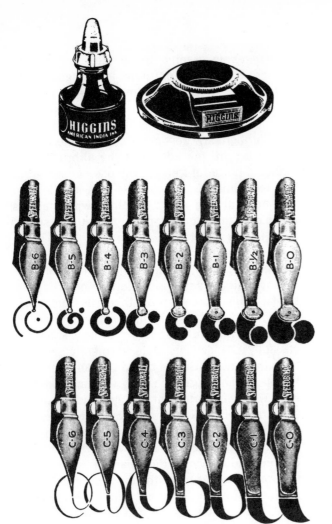

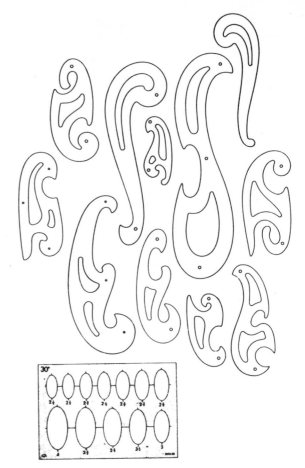

Speedball drawing pens, with ink-line·effects.

Hunt drawing pens.
22B, 56, 99, 100, 101, 102, 103, 104, 107, 108, 512, 513EF

0	1	1½	2	2½	3	3½	4	4½	5	5½	6	

Mitchell's Round Hand pen. Pen numbers are shown with corresponding ink-line effects.

Waterproof india inks come in small bottles equipped with droppers. The ink bottle should be placed in a rubber base, to prevent overturning on a slanted drawing board. Each bottle should be closed tightly after use, to prevent evaporation.

All the pen points illustrated are shown in actual size. Each pen is identified by a number that must be specified along with the manufacturer's brand name when pen points are ordered.

Transparent French curves and special templates facilitate clear and correct tracing of curves, ellipses, triangles, and symbols. Pencil or ink may be used in tracing.

Transparent water colors are available in tubes, pans, and buttons. Soluble in water, they are used for delicate washes on water-color papers or boards.

Casein colors are similar to waterproof paints used for wall painting and decorating, although they are thicker and contain finer pigment.

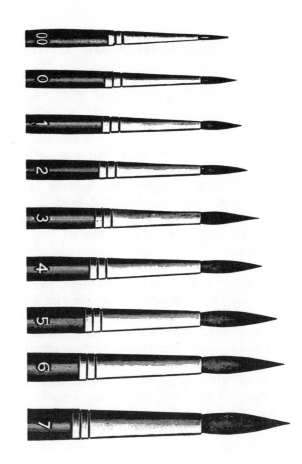

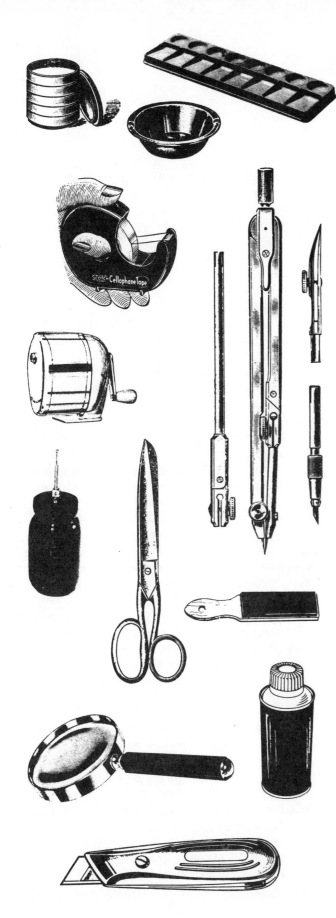

Opaque water colors are available in tubes or jars. Two coats of paint are often necessary to obtain a smooth, flat surface. A light spray of workable fixative between the two coats will ensure better results.

Mixing trays, cups, and nested saucers are available in metal plastic, and china.

The best water-color brushes are of red sable, which is obtained from kolinsky tails. Other hairs used in the making of brushes are black sable, weasel, ox, and squirrel. Good and relatively inexpensive for students' use are ox-hair brushes, illustrated above in actual size.

Compass with lengthening bar and divider, pen, and pencil attachments has many uses; it should be considered a "must" tool for cartoonists.

Miscellaneous implements: Cellophane-tape dispenser; pencil sharpener; rubber-cement dispenser; scissors; sandpaper block; magnifying glass; workable (nonglossy) fixative; utility knife.

FUNDAMENTALS OF PRINTING

It is desirable, if not absolutely indispensable, that a commercial artist have some understanding of printing processes and become familiar with the consecutive steps that lead to reproduction of his drawings in print. Brief descriptions of these steps are given below:

1. Idea

The idea is, naturally, the very first step in creative cartooning. In some instances, the artist must come forward with his own idea for a drawing, particularly in gag cartooning and syndicated panels and in promotional material for small concerns. In space advertising (ads appearing in national and trade periodicals or in newspapers), ideas are often suggested by copywriters and by creative art directors who supply layouts to be followed by the artist. Whether the material supplied is copy or layout, it should be understood fully by the artist before he proceeds with illustration. He should never hesitate to ask for explanation of points that are not clear.

2. Sketch or Layout

A sketch is a preliminary illustration of an idea. It is designed for presentation to the client. In advertising, where elements other than illustrations are important parts of an ad or of a promotion piece, the preliminary sketch is called a layout. Layouts usually contain headline, copy, illustration, and product or company identification (trademark, package, company name, etc.). Layouts are prepared on light bond or on visual paper and mounted on heavier bond or on mounting board. According to the client's request, layouts can be rough (barely suggesting what the finished art will be), semi-comprehensive (giving a better idea of the finish), comprehensive or finished comprehensive (almost finished work, with tone, and color, and details well defined). In accepting an assignment, the artist should be sure what kind of sketch his client expects from him.

Layouts are usually the same size as the final reproduction.

3. Finished Art

Art work ready for print is called finished art. This term applies to cartoons and illustrations as well as to other components of printed material, such as hand lettering, mechanicals (lines, decorations, color or shade areas), retouched photographs, etc. Finished art is usually prepared larger than final reproduction. Enlargement in art work ensures better results in reproduction; it may also help to make a better presentation effect on the client.

4. Type Composition

This is the setting in type of the text or copy. Although the cartoonist's assignment usually ends with the completion of his finished art, some knowledge of typography may be useful in enlarging the scope of his work. He may want to integrate a headline with his drawing so as to make one decorative unit, or he may feel that type of his own choice will best suit the style or the idea of his drawing. Typographic shops and printing houses have specimen books, which an artist should acquire either directly or through a friend who works with these houses. He should also learn something about type specification.

Copy is set in type by the printer or by the typographer. Printer's proofs of composition are submitted to the client for corrections; typographer's proofs are pasted up as part of the art work from which printing plates are made.

5. Printing Plates

Finished art is transferred photomechanically to metal printing plates, which are then used on the printing press to run final copies of printed material. Printing plates made photomechanically are of three types: line, halftone, and color process.

Line plates are used to reproduce black-and-white art work done with pen and ink or with the brush. For reproduction in line, each stroke of the pen or brush must be solid and opaque. Gray effects may be produced by fine black lines placed close together, but the drawn line itself may not vary from solid black.

Halftones reproduce wash drawings, photographs, and all art work containing intermediate tones of gray. These plates are prepared by photographing through a screen. The halftone screen

consists of a glass tablet covered with very thin lines that cross each other at right angles. Screens are numbered from 50 to 175, according to the number of lines along one inch of the screen. The finest screen (175) gives very detailed reproduction; the coarsest screen (50) gives a simplified picture of photographed material. Coarse screens (from 50 to 85) are used for plates to be printed on newspaper or rough paper stocks; finer screens (from 100 to 175) are used on fine-surface papers.

Color-process plates are used for halftone reproduction in full color. These plates are made by successive photographing of art work through color filters. All the colors of the rainbow can be obtained by the mixing of three transparent colors: yellow, red, and blue. In four-color-process printing, three plates are made of these primary colors, and a fourth plate, black, is added to strengthen the details of the art work.

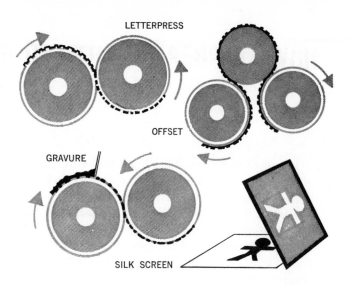

6. Printing Processes

There are several modern printing processes, or methods of printing. Before deciding which of these methods is to be used for a specific printing assignment, one must consider the following factors: the time available for the completion of the printing job; the budget for the job; the required quantity of prints; the nature of the art work to be reproduced; and the kind of paper to be used.

Below are brief descriptions of some modern printing methods:

LETTERPRESS

In this process ink is transferred from the raised surface of the plate (metal, wood, rubber, or plastic) directly to the paper. Three kinds of printing press are used for this purpose: the **platen press,** in which plate and paper meet flat, surface to surface; the **flat-bed cylinder press,** in which a sheet of paper is rolled upon a flat plate by a cylinder; the **rotary press,** in which a curved plate and a roll of paper are pressed against each other by continuously rolling cylinders.

OFFSET LITHOGRAPHY

In this process ink is transferred from a thin, flexible metal plate to a rubber **blanket,** which in turn transfers or "offsets" it to the paper. Plate, rubber blanket, and paper—in sheets or in rolls —move simultaneously on cylinders. Offset lithography allows great speeds in printing.

GRAVURE OR INTAGLIO

Instead of a raised surface as in letterpress, in gravure a **depressed** surface is used to transfer ink directly to the paper. Tiny cells, or depressions, of different depths are etched on a copper cylinder or plate to contain ink. Ink is transferred by direct contact of plate and paper. Gravure presses also are made for printing on paper sheets or rolls.

SILK SCREEN

Silk-screen printing, unlike the preceding methods, uses silk, organdy , or metal mesh as a screen through which ink is pressed directly to paper, wood, or other material. Design and lettering are cut from strong paper and glued under the screen; a film stencil prepared photographically may be used. The silk-screen process is used for small printing orders only.

COLLOTYPE OR PHOTOGELATIN PROCESS

This method unlike letterpress, offset lithography, and gravure, allows printing in a continuous tone, without resort to screens. A glass plate coated with gelatin of varying density is used to transfer ink directly to the paper.

HOW TO PREPARE ART FOR REPRODUCTION

In advertising, as in all other fields using printed material, the process of organizing art work for reproduction is called **production.** The two basic steps of reproduction are platemaking and printing. All art work ready for reproduction is called **finished art.** This term applies to illustrations as well as to retouched photographs, hand lettering, mechanicals, type, etc.

One of the most important factors in obtaining faithful reproduction of finished art is the artist's understanding of the processes that are used to reproduce his work. Also, the artist should have enough knowledge of production to be able to follow his clients' instructions about the preparation of finished art.

Usually, drawings are made for either line or halftone reproduction. The following illustrations show one basic subject executed in some of the various media available to the artist. Each illustration is prepared in a manner suited to one of the typical photomechanical methods of platemaking.

Drawings for Line Reproduction

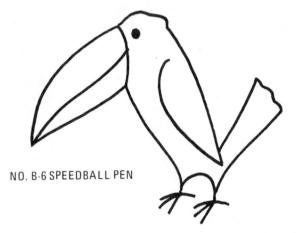

NO. B-6 SPEEDBALL PEN

Plate- or kid-finish papers or illustration boards should be used for pen-and-ink drawings. A good-quality paper surface will prevent uncontrolled spreading of ink and will allow correction by rubbing with an ink eraser or by scratching with a razor blade or scratch point.

Ink as well as opaque or transparent water colors may be used. Excess ink or paint should be taken off the brush by painting a few strokes on a scrap of paper. Dry-brush effects are obtained by painting with a half-wet brush on a grained paper surface.

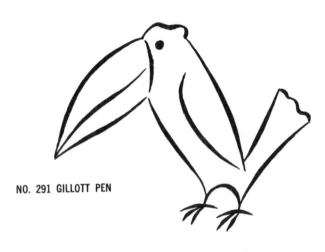

NO. 291 GILLOTT PEN

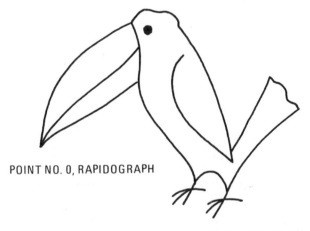

POINT NO. 0, RAPIDOGRAPH

Pencil drawings, after completion, should be sprayed with nonglossy fixative to protect the drawing and to allow more efficient correction with opaque white.

Scratch board is a board covered with a smooth, white coating resembling plaster. Areas on which it is desired to work are painted with a thin coat of black india ink, which is absorbed by the surface coating, drying instantly. After the

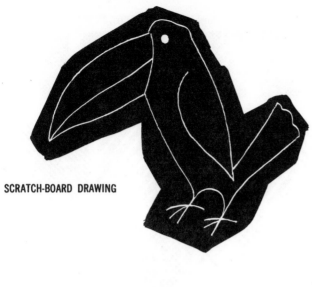

SCRATCH-BOARD DRAWING

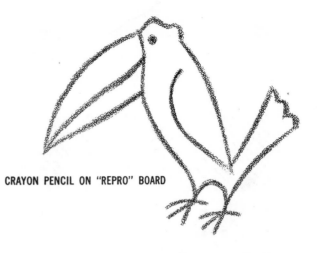

CRAYON PENCIL ON "REPRO" BOARD

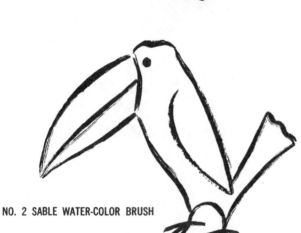

NO. 2 SABLE WATER-COLOR BRUSH

A variety of textured surfaces is used for this drawing technique. The textured papers are widely used by political, sports, and other cartoonists working for newspapers. Below are several examples of pencil effects on different "repro" boards.

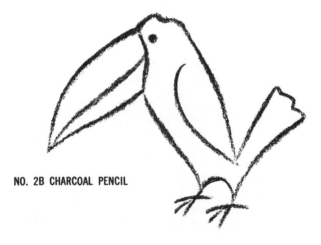

NO. 2B CHARCOAL PENCIL

sketch is transferred from a tracing to this blackened surface, a stylus or other sharp-pointed instrument is used to scratch lines of the tracing through the surface of the black ink, revealing the white subsurface.

Screens

When effects of even-values of gray are desired, Ben Day screens (shading films) are used either by the platemaker in the photomechanical process, or by the artist who applies the screens directly to finished art.

Screen patterns are even-dotted, 10% - 80% shades of black, graduated tones, cross-hatchings, grids, and other designs, some available in white as well as in black.

The artist covers with a patch of screen the areas to be shaded, and then cuts away the superfluous parts with a X-Acto knife. The burnishing of the screen, and taping of protective tracing over the completed work, makes the art ready for reproduction in Line and Ben Day (see page 25.)

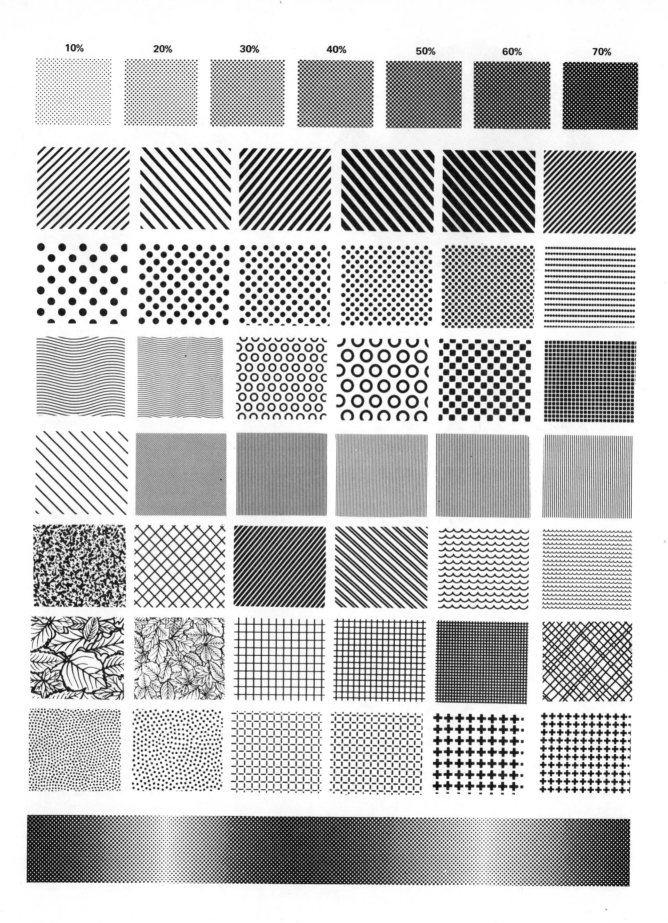

10% 20% 30% 40% 50% 60% 70%

Drawings for Line and Ben Day Reproduction

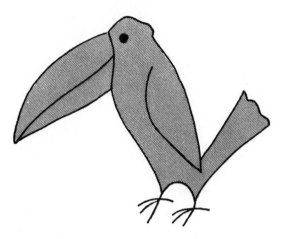

Pen-and-ink drawing with 30% screen for Line and Ben Day reproduction.

Pen-and-ink drawing with 60% screen for Line and Ben Day reproduction.

Drawings for Halftone Reproduction

The original drawing is the same size as the reproduction below. It was made for halftone reproduction without concern for the technicalities of platemaking. However, different types of halftone reproductions can be made from the same drawing in accordance with instructions given to the platemaker. See the examples shown on the following pages.

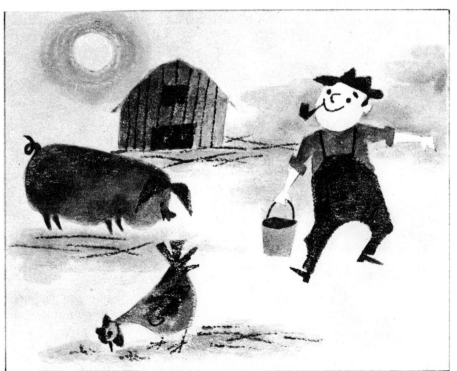

Square Halftone

A rectangular area is covered entirely with screen dots of different sizes. White highlights are covered with a very fine, hardly visible screen of black dots.

Drop-out Square Halftone

White areas are cleaned of screen dots, or dropped out. A sharper, more contrasty effect is achieved in this way.

Silhouette Halftone

The drawing's outside edges are sharply outlined, or silhouetted, from the surrounding white background. White areas inside the drawing are covered with a fine screen.

Drop-out Silhouette Halftone

The drawing is silhouetted. White areas inside the drawing are dropped out.

Vignette Halftone

The outside edges of the drawing are made to blend softly with the background.

Drop-out Vignette Halftone

Vignette halftone with white inside the drawing dropped out.

Veloxes

Finished art ready for reproduction can take the form of a photographic print whose image, before going to the platemaker, is already converted into halftone dots. Such paper prints are called **Veloxes**. The artist can work on a Velox with black or white paints, cut away parts of it, paste it on a mechanical, etc. The platemaker can make a line plate from a Velox. Line reproductions made from Veloxes have the appearance of halftones, but their cost is considerably lower.

Color Separation

If art work is to be printed in more than one color, a separate plate is needed for each color. With the exception of process-color printing, in which separation of colors is done photomechanically, all printing methods require color or Ben Day separations prepared and indicated by the artist.

One way to indicate which areas of art work are to be printed in color or screened is to outline these areas with a red line and to add instructions for the engraver about the desired color or screen. Color placement may be indicated on a tracing covering the art. Red-ink outlines are understood by the platemaker as mere color guides that are not to be printed.

Another way to prepare color-separation art is through the use of overlays.

Overlays

A sheet of frosted or clear acetate, tracing Vellum, or translucent masking film taped over the basic drawing are called overlays. When art in more than one color has to be pre-separated, one overlay is needed for each color. Both the drawing and its overlays must be provided with registration marks which are available as adhesive tapes.

Color areas are drawn or painted with black India ink on acetate overlays, or cut with X-Acto knife from masking film. The masking film is translucent, thus allowing the artist to work with more precision. Cutting and stripping of film in preparing the overlay is an easy and time-saving method.

After the overlay art is completed, registration marks are placed carefully in corresponding positions, color swatches attached to the overlay, and the name of color written on it.

When Line-and-Ben Day art requires pre-separation, the shades of grays are prepared on the overlays in the same manner as color, with indication of desired Ben Day percentages.

Bourges Sheets

Bourges overlay or adhesive sheets can be used for color-separation jobs. These transparent red sheets allow the artist to see through the color overlay and, therefore, to work with great accuracy. Transparent red liquid color can be used for line details. Transparent red photographs well and thus takes the place of black-color overlays.

Bourges sheets come in various other colors, also. In preparing color-separation copy in two, three, or more colors, separate overlays are used in the desired colors. What is on each overlay photographs black, but in the reproduction process the printer uses inks of precisely these desired colors. Booklets on how to use these and other Bourges materials are obtainable in art-supply stores.

Highlight Drop-out Techniques

In seeking speedier and less costly methods of converting black-and-white art work into halftone plates with white highlights, the photoengraving industry has devised several automatic drop-out processes. By using special materials, the artist can prepare for halftone reproduction finished art that eliminates costly and time-consuming halftone masking, opaquing, and tooling. These processes include Kemart, Kromolite, and Fluorographic.

Kemart

This technique allows the artist to prepare black-and-white finishes freely, using pencil, crayon, opaque, or transparent washes on Strathmore-Kemart fluorescent boards and papers. All the areas not covered by drawing or paint appear

in reproduction as whites. Kemart Quencher must be used instead of water to dilute washes (india ink should not be used as a wash). Kemart Highlight White is applied to all areas to be highlighted. Purple light from a special lamp makes the fluorescent (highlighted) areas in art copy visible to the artist. Finished art should be labeled "Kemart."

Kromolite

Used primarily for wash drawings, this process allows work with opaque as well as transparent water colors. Kromolite Highlite solution replaces water to obtain opaque or transparent grays. Completed art work is sprayed with Kromolite Spray solution. All washes become yellow-greenish, and all blacks and whites remain intact. Highlight drop-outs and other white areas are obtained by the application of Kromo-white. Finished art should always be plainly labeled "Kromolite."

Fluorographic

In this process, the artist can use only transparent washes. Black water color or india ink is mixed with Fluoro Solvent instead of water. Areas not covered with wash or with Fluoro Highlight white will reproduce as halftone dots. Only very white illustration boards should be used. Fluorographic pencils also can be used, either alone or in combination with washes. The artist controls the fluorescent effects of his drawing under ultraviolet light. Finished art should be labeled "Fluoro" before going into production.

All art work prepared with Kemart, Kromolite, or Fluorographic materials is handled only by photoengravers and lithographers licensed and equipped by the manufacturers of these materials.

Several types of registration marks

REFERENCE FILES

Reference files, known also as "morgue" or "scrap" files, are invaluable to a commercial artist, for nearly every assignment in commercial art requires some use of reference material.

Most cartoonists, in their work, represent real situations, real objects, and real people (the word "real" as used here applies also to the legendary and mythological). It seems obvious that, in order to interpret an object correctly, one should be familiar with it. An incorrect drawing of an object appearing in print will be sure to bring criticism and protests from readers who know this object better than the artist. Therefore, the essential, identifying details of objects, people, and motions should be preserved in all interpretive drawings. When distortion, stylization, or deletion of details is in order, it should be done with reference to actual appearances. It is impossible for an artist to memorize all the details of a multitude of objects, appliances, machines, sports motions, historical costumes, etc., so the use of reference material becomes indispensable.

Every commercial artist should have a file that fits his personal needs—his personal illustrated dictionary. The compilation of a good reference file, it should be noted, is a lifetime job. New clippings from newspapers, magazines, and brochures should be added continually to the file; old clippings should be eliminated to provide space and avoid crowding of the folders. Clippings easy to acquire—for example, automobiles, clothing, and appliances—tend to accumulate quickly and in duplication. Very recent or very ancient items are most likely to be needed for reference. Therefore, it is advisable to keep complete files of ancient items, but to renew, at frequent intervals, the files of current articles. It should be emphasized that a small file containing only usable material is better than a large file crammed with white elephants. Also, a small quantity of filed material is more easily remembered; and knowing what reference is available and where it can be found will save much time in research.

Some clippings might fit into more than one folder; they should be placed in any one of these. An unsaddled, running horse will fit in either the farm-animal or the horse-racing category. It is up to the artist to decide where to file such a horse and to remember his decision.

Other clippings don't fit precisely into any of the categories. These should be placed in a related category.

Pictures showing groups of diversified items should be filed where they are most likely to be remembered. A picture showing a policeman standing near a car parked in front of a church could be filed under "Religion," "City Services," or "Automobiles."

In filing the work of other catoonists, one should consider whether the clipping would fit better in one of the "Cartoons" categories or under objects, sports, animals, etc.

Clippings should be collected whenever a chance occurs and stored temporarily in a folder provided for this purpose ("Clippings to be Filed," No. 100 on our classified file list below). Once or twice a month, all collected material should be filed in appropriate folders. The superfluous paper surrounding the picture should be cut away. If useful information about the picture is attached, it should either be left or transcribed on the margin of the picture. Should a folder become too bulky, another bearing the same number may be added to the file, marked with an additional "A," and filed in succession.

A list of folders in the file, similar to the list suggested at the end of this chapter, should be prepared on a piece of illustration board and placed conveniently near or inside the file.

In addition to these files, every artist should have an illustrated dictionary and possibly some illustrated reference books on such subjects as Science, Costumes, Flowers, Animals, Birds, etc. Mail-order-house catalogues (Montgomery Ward; Sears & Roebuck) are excellent references and not too difficult to obtain. In New York City, the picture collection of the New York Public Library often comes to the rescue of those with insufficient files of their own.

1. ADVERTISING
Interesting advertisements/ Original ideas and unusual design/ Window displays/ Mannequins/ Outdoor advertising constructions/ Signs

2. AGRICULTURE
Farms/ Barns/ Farm equipment and machinery/ Tools/ Farmers

3. AIRCRAFT, CIVILIAN
Airplanes/ Airports/ Airport vehicles and Installations/ Parts/ Insignia and symbols/ Pilots' uniforms

4. AIRCRAFT, MILITARY (USA AND FOREIGN)
Airplanes/ Airports/ Weapons/ Missiles/ Bombs/ Uniforms/ Insignia

5. ANATOMY
Human body/ Male and female nudes/ internal organs/ Hands and feet/ Statues/ Anatomical diagrams

6. ANIMALS, WILD
Lions/ Tigers/ Giraffes/ Monkeys/ Jungle animals/ Forest animals/ Field animals

7. ANIMALS, FARM
Cows/ Pigs/ Sheep/ Horses/ Donkeys/ Others /

8. ANIMALS, PET

9. ANIMALS, OCEAN, RIVER, AND LAKE

10. ANIMALS, VARIOUS (ALSO FANTASTIC AND LEGENDARY)

11. ARMY AND OTHER MILITARY BRANCHES, USA (EXCEPT NAVY AND AIR FORCE)
Uniforms/ Armaments/ Camps/ Installations/ Vehicles/ Insignia

12. ARMY AND OTHER MILITARY BRANCHES, FOREIGN (EXCEPT NAVY AND AIR FORCE)

13. ART
Famous works/ Famous artists (USA and Foreign)/ Museum interiors

14. ASTROLOGY
Drawings and photographs of planets/ Zodiac signs/ Constellations

15. AUTOMOBILES, MODERN
Passenger cars of all makes/ Trucks/ Buses/ Accessories/ Engines/ Tires/ Gas Stations/ Garages/ Attendants and chauffeurs

16. AUTOMOBILES, ANCIENT

17. BIRDS
Wild/ Farm/ Domestic/ Fantastic

18. BOATS
Ocean liners/ All ancient and modern vessels (except sport and Navy)/ Ports (USA and foreign)/ Port installations/ Instruments/ Sailors

19. BOATS (USA AND FOREIGN NAVIES)
Battleships/ Aircraft carriers/ Destroyers/ Submarines/ Others/ Ship installations and weapons/ Navy uniforms and insignia

20. BUILDINGS, CITY

21. BUILDINGS, SMALL-TOWN AND SUBURBAN

22. BUILDINGS, COUNTRY

23. BUILDINGS, FAMOUS (USA)

24. BUILDINGS, FAMOUS (FOREIGN)

25. CARTOONS, ADVERTISING

26. CARTOONS, COMIC

27. CARTOONS, GAG

28. CARTOONS, EDITORIAL AND OTHER

29. CHARTS

30. CHILDREN
Babies and school children/ Toys/ Cribs/ Nursery/ Furniture and furnishings/ Games

31. CIRCUS, SIDE SHOWS, AMUSEMENT PARKS
Performing animals/ Clowns/ Acrobats/ Tents and installations

32. CITY SERVICES
Police/ Fire Department/ Ambulance/ Sanitation department/ Utilities

33. CITY, VARIOUS
Streets/ Bridges/ Parks/ Traffic signs/ Beaches/ Zoo/ Stores

34. COLLEGE
Grounds/ Buildings/ Campus installations/ School facilities/ Students/ Graduation scenes/ College events

35. COUNTRYSIDE
Landscape/ General views/ General store /Local color

36. DANCE
Ballet/ Folk (USA and foreign)/ Costumes/ Social

37. FASHION, MEN
Clothing throughout history/ Modern and historical accessories .

38. FASHION, WOMEN
Clothing throughout history/ Modern and historical accessories

39. FOOD AND DRINK
Packaged products/ Food stores/ Supermarket installations

40. FOREIGN COUNTRIES, AFRICA

41. FOREIGN COUNTRIES, CENTRAL AMERICA

42. FOREIGN COUNTRIES, NORTH AMERICA

43. FOREIGN COUNTRIES, SOUTH AMERICA

44. FOREIGN COUNTRIES, ASIA (including all of Soviet Union)

45. FOREIGN COUNTRIES, EUROPE

46. FRUITS AND VEGETABLES
Raw and cooked/ Dinnerware/ Silverware/ Table arrangements

47. GAMES
Outdoor and indoor/ Cards/ Chess/ Roulette/ Darts/ Billiards/ Others

48. HEALTH
Hospitals, interiors and exteriors/ Operating rooms/ Laboratories/ X Rays/ Doctors and nurses/ Surgical instruments/ Dentist's office

49. HOLIDAYS, CHRISTMAS

50. HOLIDAYS, EASTER

51. HOLIDAYS, NEW YEAR

52. HOLIDAYS, THANKSGIVING

53. HOLIDAYS, VARIOUS
Celebrations/ Parades/ Birthdays/ Labor Day/ Valentine/ Mother's Day/ Father's Day/ Saint Patrick's Day/ April Fool's Day/ Passover/ Others

54. INDUSTRY
Plants/ Installations/ Machinery/ Workers outfits/ Mining/ Prospecting/ Oil refineries/ Steel mills

55. INSECTS

56. INTERIORS, BATHROOM AND KITCHEN
(All Interiors folders contain related furnishings, utensils, gadgets, etc.)

57. INTERIORS, BEDROOM

58. INTERIORS, LIVING ROOM

59. INTERIORS, VARIOUS
Furniture and furnishings throughout history

60. JUSTICE
Prisons/ Police/ Sheriffs/ Judges/ Courtrooms/ Justice of the past/ Guillotine/ Medieval torture instruments

61. LETTERING
Unusual design in lettering/ Type-specimen books

62. MAPS
USA and foreign/ Illustrative maps/ Various projections/ Globes

63. MUSIC
Musical instruments/ Orchestras/ Opera/ Musicians/ Phonographs/ Radio

64. MYTHOLOGY

65. OFFICE
Office scenes/ Furniture/ Equipment/ Furnishings

66. ORNAMENTS
Modern/ Classical/ Folklore/ Architectural decorations

67. PORTRAITS (USA)
Photographs, drawings, and caricatures

68. PORTRAITS (FOREIGN)
Photographs, drawings, and caricatures

69. RELIGION
Churches/ Priests/ Weddings/ Funerals/ Biblical personalities and scenes/ Religious symbols/ Liturgical art/ Vatican/ Mecca/ Synagogues/ Roman and Greek temples

70. RADIO AND TELEVISION
Sets and parts/ Actors and personalities/ Studios and installations

71. RESTAURANTS
Exteriors and interiors/ Bars/ Nightclubs/ Waiters/ Cooks/ Doormen

72. SCIENCE
Scientific instruments/ Microscopes/ Laboratory equipment/ Optical instruments/ Electricity/ Nuclear physics/ Chemistry/ Scientists

73. SPORTS, BASEBALL

74. SPORTS, BASKETBALL

75. SPORTS, BOATING

76. SPORTS, BOXING AND WRESTLING

77. SPORTS, FISHING

78. SPORTS, FOOTBALL

79. SPORTS, GOLF

80. SPORTS, HORSEBACK RIDING AND RACES

81. SPORTS, HUNTING

82. SPORTS, TENNIS

83. SPORTS, TRACK

84. SPORTS, WATER

85. SPORTS, WINTER

86. SPORTS, VARIOUS

87. SYMBOLS
Symbolic objects, signs, emblems, and figures

88. THEATER AND MOVIES
Stage/ Backstage/ Plays/ Actors/ Settings/ Costumes/ Theater throughout history/

89. TRAVEL, SURFACE (EXCEPT AUTOMOBILES)
Railroads/ Old and new locomotives/ Stations/ Luggage/ Horse-driven vehicles

90. USA, HISTORY
Indians/ Pilgrims/ Quakers/ Colonial period/ Revolutionary War/ Civil War/ Scenes and personalities

91. USA, MONUMENTS AND LANDMARKS

92. USA, OVERSEAS

93. USA, EAST

94. USA, WEST

95. USA, NORTH

96. USA, SOUTH

97. VACATION
Picnics/ Outings/ Camping/ Beaches/ Hiking/ Mountain climbing/ Other

98. WEAPONS THROUGHOUT HISTORY

99. WORK
Arts and crafts/ Work and workers not covered by other folders/ Tools and equipment

100. CLIPPINGS TO BE FILED

Note: Besides reference files, many artists will find it useful to keep customer files containing all material connected with actual jobs done for clients. This will include scraps of art work, photostats, photographs, trademarks, logos, etc.— all material usable on future jobs for the same clients.

FIRST STEPS IN CARTOONING

Every student seeking to become a professional cartoonist should begin his studies with confidence in his ability to learn and succeed. Reasonable self-confidence can help greatly—with it one can achieve better results faster. Such self-confidence is seldom misplaced, because, just as nearly everyone can learn to read and write or to play a musical instrument, so nearly everyone can learn to draw. With respect to talent, only very few start in rags and end in riches, so to speak, and most artists' destiny is somewhere between the two extremes.

The eleven sections of this chapter reveal the working procedures covering specific aspects of cartooning. These aspects can be summed up in one basic principle—believability. Cartoonists use simplified or exaggerated forms, but these forms, nevertheless, should give a convincing impression of reality. Figures are unified wholes capable of coordinated action. Their arms, legs, heads, and torsos seem to fit together, and they themselves seem to belong to their surroundings, as indicated by background details.

How the cartoonist accomplishes these results is shown in the pages that follow. The drawings illustrating steps and procedures, it will be noted, vary in style according to the functions that they demonstrate. At times, the drawings are simplified to the point where they closely resemble schematic diagrams. Detail is stripped away to reveal action, structure, or expression more clearly.

Perhaps the first task to be mastered in mak-

ing cartoon forms thoroughly believable is the suggestion of motion. Three consecutive steps are recommended in the study of motion:

VISUAL STUDY. Observe carefully each of the spots illustrating a specific action, and compare the spots with one another. Notice the diversity of positions that can depict the same action, the differences and similarities among these positions. For example: all jumping figures have both feet off the ground, but the feet may be placed in different positions; all walking figures have both feet touching the ground, etc. While studying the sketches visually, convert them mentally into real-life situations: imagine real people in action indicated in the drawings. Later on, as a creative cartoonist, you will often reverse this process. You will look at real people and then convert their movements and expressions into humorous drawings.

TRACING. Put a sheet of tracing paper over each page of drawings, and trace them with an HB pencil. All the drawings are sketchy, so as to discourage you from copying them literally. You should be able to repeat the movement without copying the style. Redraw your sketches on the back of tracing paper with a 2B pencil, and then transfer them to drawing paper. Finally, finish up the drawings with pen, brush, or other medium. In this way you will have drawn each spot three times: to the right, to the left, and with ink.

EXERCISES. Follow exercise suggestions for each part of the chapter. The more you exercise, the faster you will reach proficiency in cartooning.

CHOOSING THE RIGHT MEDIUM

Doodling with pencils, pens, and brushes on different paper surfaces may prove helpful to beginners in choosing the drawing technique to be applied throughout their first steps in cartooning.

The student may find one technique more appealing than another because he has tried it before as a child or in school and, therefore, is more familiar with it. Also, one's manual hobbies and habits, degree of dexterity, or the "feel" of drawing media—any of these may be the reason for one's inclination toward one drawing technique or another. The visual effect produced on the artist by his own drawing may appeal to him for a host of psychological and emotional reasons.

After choosing one technique, the student should apply it throughout the whole course in order to simplify his training and make it easier.

Doodling exercises below are made on Strathmore drawing paper, kid finish.

THE HUMAN FIGURE

There are a number of concepts of what are the "ideal," "classical," "real," or "average" proportions of the human body. One of the most popular is based on Michelangelo's figure drawings, according to which the height of an erect man's body is eight times the height of his head. Wooden manikins available in art-supply stores are usually built according to these proportions.

These manikins are adjustable to desired positions; therefore, they can be used by cartoonists for practicing action drawings. Manikins are invaluable, especially to those artists who have already developed a style of their own and who are consequently capable of drawing from a manikin without repeating its proportions, for these proportions should be used only in very realistic cartoons and illustrations. The need for humor in cartoon drawings makes necessary a good deal of interpretation and distortion of "real" proportions in order to put emphasis upon comic actions or features.

A typical American family is composed of four members: father, mother, one boy, and one girl. There should be at least three years difference in the age of children. The mother should be about one half-head smaller than the father. When several children are drawn, their age is determined approximately by their faces, by the kind of clothes they wear, and by their comparative sizes.

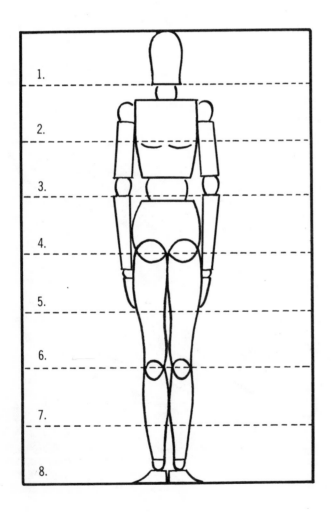

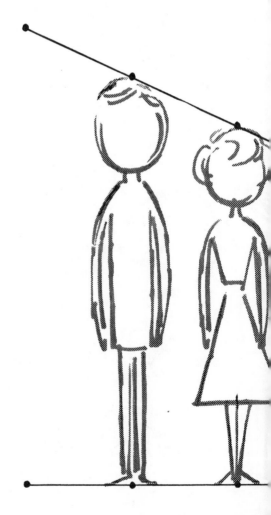

The family of seven sketched on these pages suggests a method of defining children's sizes roughly according to their age. Several other features should also be noticed when studying this drawing:

1. Proportions within figures are arbitrary; they do not correspond to the manikin's. The height of the man's body is only 4½ times the height of his head. All the heads are larger than normal in relation to their bodies; and, as to the youngsters, the younger the child, the larger his head in proportion to his body. The legs of all the males in the family are shorter than they would be normally, but the legs of the females are of normal length to prevent ugliness.

2. The style of these drawings (as well as the style of all drawings in "First Steps in Cartoon-ing") is sketchy in order to discourage students from too literal repetition of lines during tracing exercises.

3. Clothing is schematic and undetermined, in order to emphasize only what is important in this drawing: the relative sizes and individual proportions of figures.

4. There are no facial features, for the same reason as above. The only details on heads are the suggestions of hairdos that help to identify the ages of the figures.

When a side view of figures is shown, some rules of perspective should be observed. All parallel lines drawn through the extremities of standing figures should come together on the horizon, where they meet at vanishing points (see the chapter "Perspective").

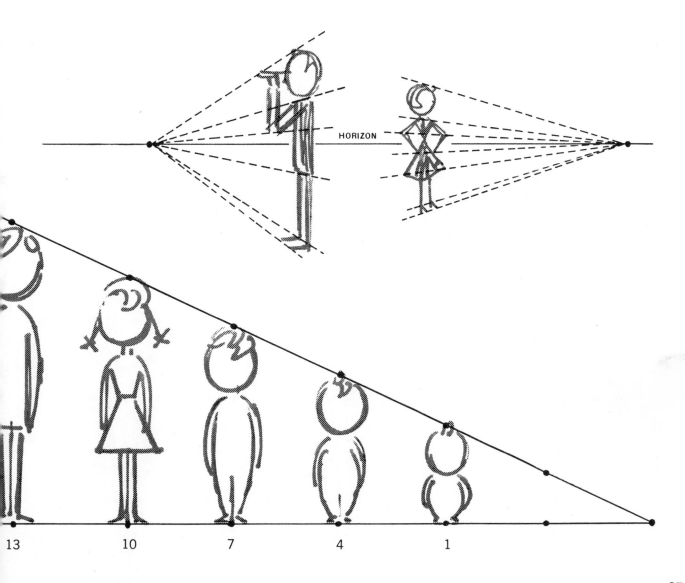

HORIZON

13 10 7 4 1

HEAD AND FACE

A complete study of the human head should include anatomy, perspective, and some exercise in life drawing. A working knowledge of the structure of the skull and of the facial muscles is indispensable to cartoonists with realistic and semirealistic styles and very helpful to those with more interpretive styles.

Drawing the head in correct perspective accurately determines the head's position in relation to the body, thus helping to accentuate or explain various actions of the whole figure.

Besides the perspective of the head, there are three basic problems facing cartoonists in the drawing of human faces: humorous proportions of facial features, humorous facial expressions, and ages of figures.

In the drawings below, the stylized faces of adult males are drawn as ovals viewed at eye level. The tinted drawing shows the average proportions of facial features. A horizontal and a vertical line divide equally the rectangle in which the head is contained. These two lines intersect at a point, which marks the root of the nose. Both eyes and the upper tips of the ears are on the horizontal line along with the root of the nose. The upper half of the rectangle above this line is divided into three parts, and the top third determines the hair line. The lower part of the rectangle is divided in half by a horizontal line on which the base of the nose and the lower extremities of the ears are placed. The mouth is on the upper third of the distance between the base of the nose and the chin.

All the schematic drawings are restrained in their humorous exaggeration, so that students will feel less inhibited in using their own sense of humor and caricature.

HUMOROUS PROPORTIONS

Humorous effects in the face are produced by exaggerating or distorting the average measurements and relative proportions within facial features. When the caricature of a person's face is being drawn, all the characteristic irregularities should first be observed and then exaggerated. The extent of this exaggeration determines whether the caricature will be "mild" or "strong." The more regular (closer to average) the subject's features, the more difficult the conception of a resemblant caricature. People with too long or too short noses, with mustaches or beards, or with oddly shaped faces, are the easiest subject for caricature.

In order to simplify the study of facial caricature, only three types of distortion are applied in the schematic drawings below: displacement of features, changes in hairlines, and reshaping of noses. The over-all shapes of faces, the sizes and

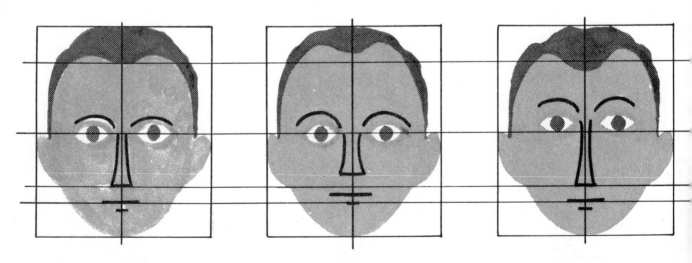

Average type: regular features.

Jovial type: short, wide nose; receding hairline

Serious type: long, narrow nose; small forehead

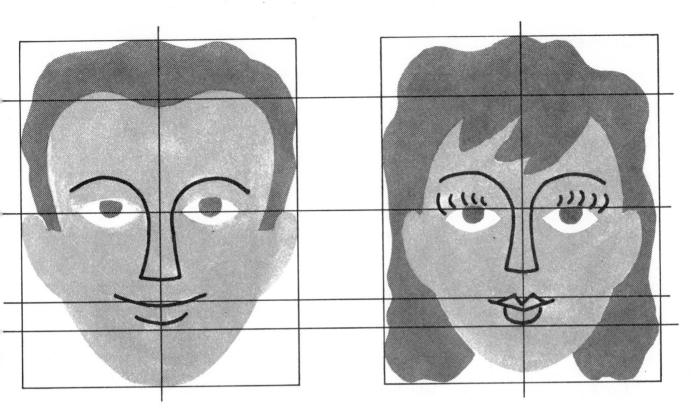

form of mouths, eyes, eyebrows, and ears are left unchanged.

Consistency of style should be preserved in caricatures of men and women. Exaggeration of female features should be somewhat attenuated in comparison with corresponding male features: rounder face, smaller mouth and nose, etc. Details, such as eyelashes and lips, are added.

EXERCISE:

Draw faces of men, women and children. Distort their features in various combinations. Try to draw caricatures of real people, from life or from photographs. Draw caricatures of the following types: strong, weak, healthy, sick, fat, thin, gay, sad, handsome, and homely.

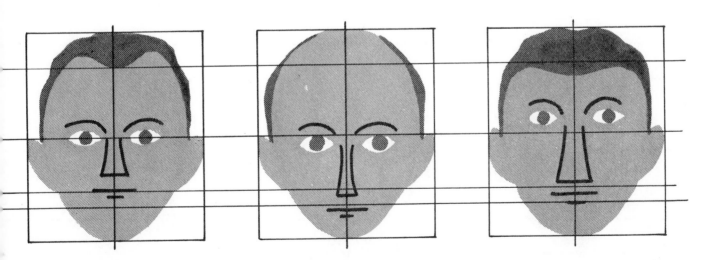

Athletic type: short, wide nose; long chin

Intellectual type: high forehead; small chin

Ordinary type: long, wide nose; small forehead

HUMOROUS EXPRESSIONS

To accentuate humorous expressions, distortion of facial features is indispensable. The drawings below show some of the facial expressions now current in cartooning—but the range of nuance and variation in these expressions is virtually limitless. The drawings are moderate in tenor, to encourage students in their own search for individual styles in interpreting facial moods.

When there is need for more punch in humorous expression, the face and features both are considerably distorted and act jointly to produce the desired effect of exaggeration.

Facial expressions in the drawings on these pages are achieved without changing the shape of the faces and by using only a minimum number of details.

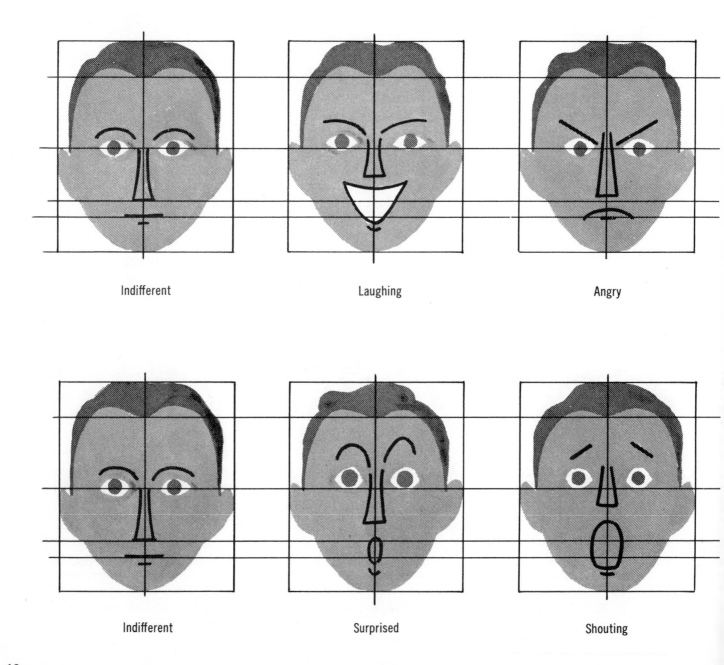

Indifferent Laughing Angry

Indifferent Surprised Shouting

40

EXERCISE:

Draw imaginary faces of men, women, and children expressing the following moods: boredom, love, doubt, pleasure, gaiety, suspicion, drunkenness, amazement, despair, elation, pride, hunger, contempt, arrogance. Change over-all shapes of faces to emphasize different moods. Use a minimum of details. Make several drawings expressing the same mood in various intensities.

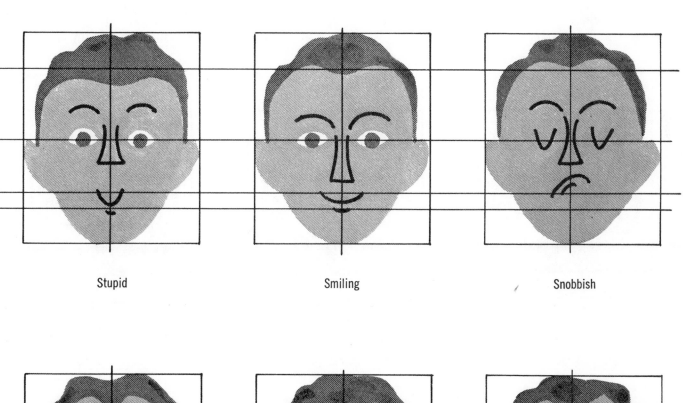

Stupid Smiling Snobbish

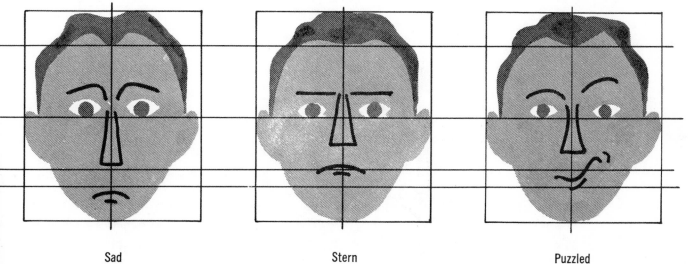

Sad Stern Puzzled

AGE

Age in cartoon faces can be depicted only approximately. Aging produces the following changes in the human face: receding and graying of hair, more angular contour of the face, double chin, wrinkles, and dropping of the corners of mouth and eyebrows.

The age of cartoon figures can be defined with more precision by suggesting the position of the head in relation to the neck and shoulders. The posture of aging persons becomes less erect, and their shoulders sag.

The six age categories pictured below are generally sufficient to accommodate age requirements in drawings of male adults.

The comparative measurements of adult and infant faces are shown in the illustration on the facing page.

By dividing the head of an adult horizontally in two equal parts and the head of an infant in three equal parts, it becomes easy to establish their comparative proportions graphically.

As the infant grows older, the upper two thirds of his head become proportionately less prominent. His forehead recedes and becomes smaller in proportion to the rest of his face.

But, at all ages, the base of the nose is half way between the eyes and the chin, and the mouth is on the upper third between the nose and the chin.

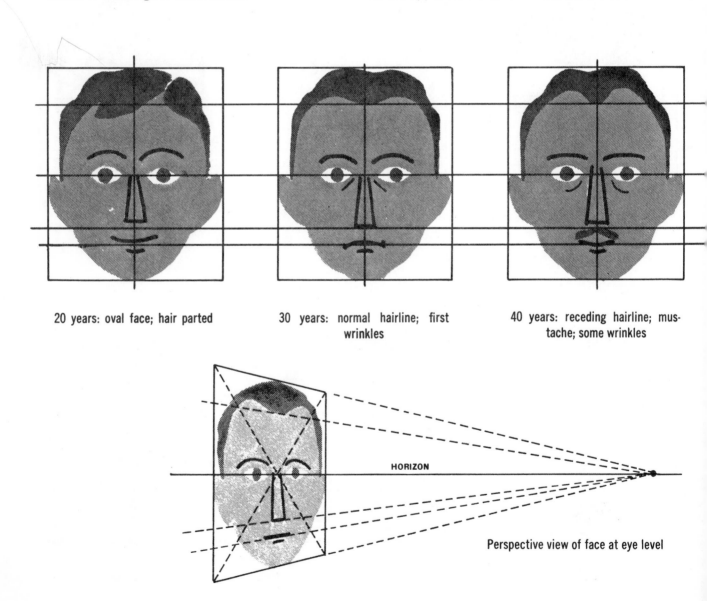

20 years: oval face; hair parted

30 years: normal hairline; first wrinkles

40 years: receding hairline; mustache; some wrinkles

HORIZON

Perspective view of face at eye level

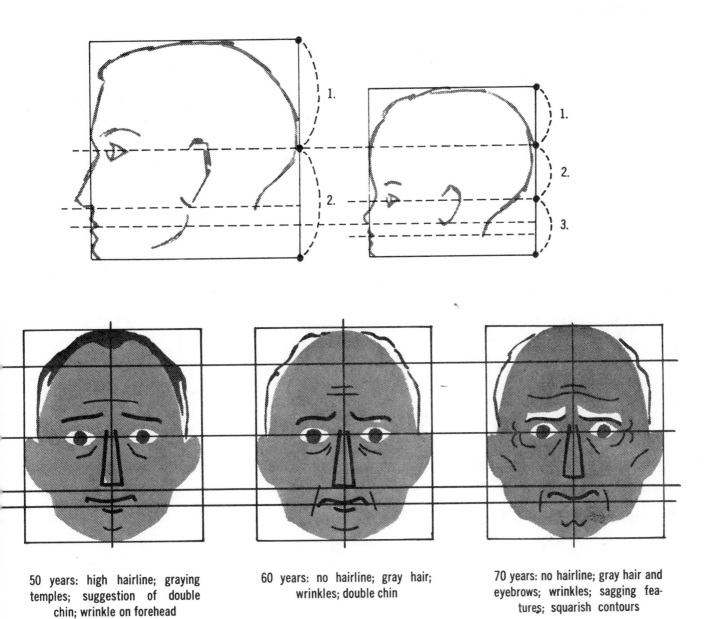

50 years: high hairline; graying temples; suggestion of double chin; wrinkle on forehead

60 years: no hairline; gray hair; wrinkles; double chin

70 years: no hairline; gray hair and eyebrows; wrinkles; sagging features; squarish contours

EXERCISE:

Draw faces of men and women of different ages. Add mustaches and beards to male faces. Place heads on necks and add shoulders to help determine age of figures. Be lenient with women: a woman of 50 should not look more than 40.

HANDS AND FEET

Hands and feet play an important contributory role in emphasizing the motions of the human body and in reinforcing the facial expressions. The position of the hands, their size in proportion to the body, and the movements of fingers have to be considered carefully in all cartoon situations.

The drawing below shows in a simplified manner the mechanics of finger movements. Whereas all the fingers radiate from a point in the center

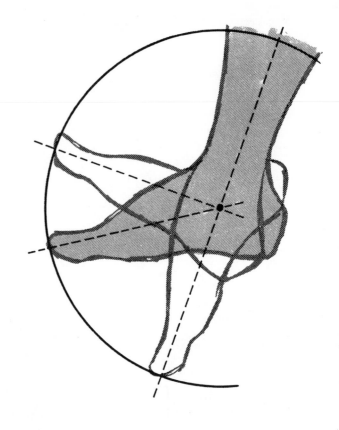

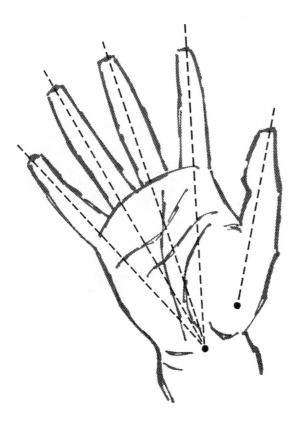

of the wrist, the thumb moves from a point located above and on the side of this center. This schematic rule applies to the hands with extended fingers or in relaxed positions.

The foot moves toward or away from the leg along an imaginary circle that has its center in the middle of the ankle.

A dancer's foot can be stretched till it forms a straight line with the leg. It can be raised so that the toes travel 90° around the circle.

HUMAN FIGURE IN MOTION

BASIC MOTIONS

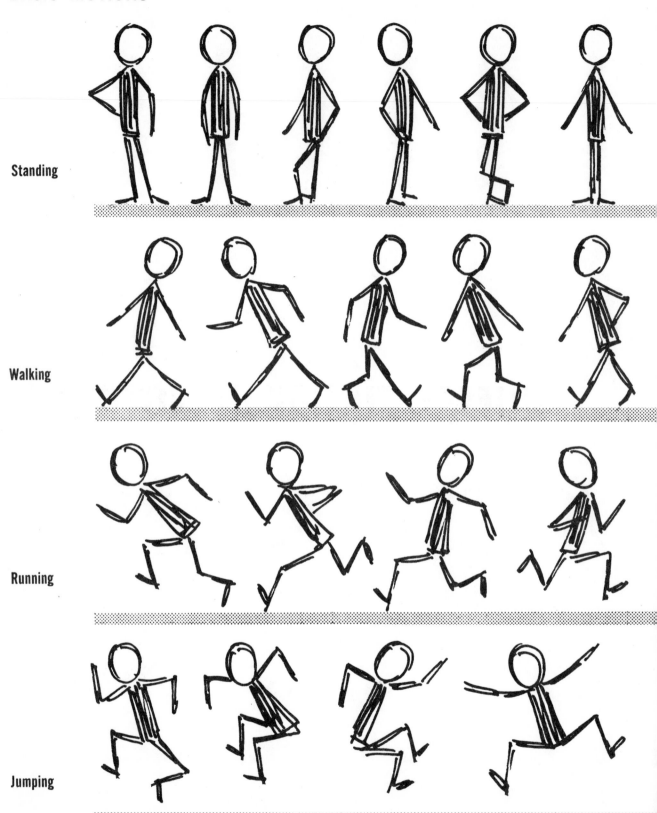

Standing

Walking

Running

Jumping

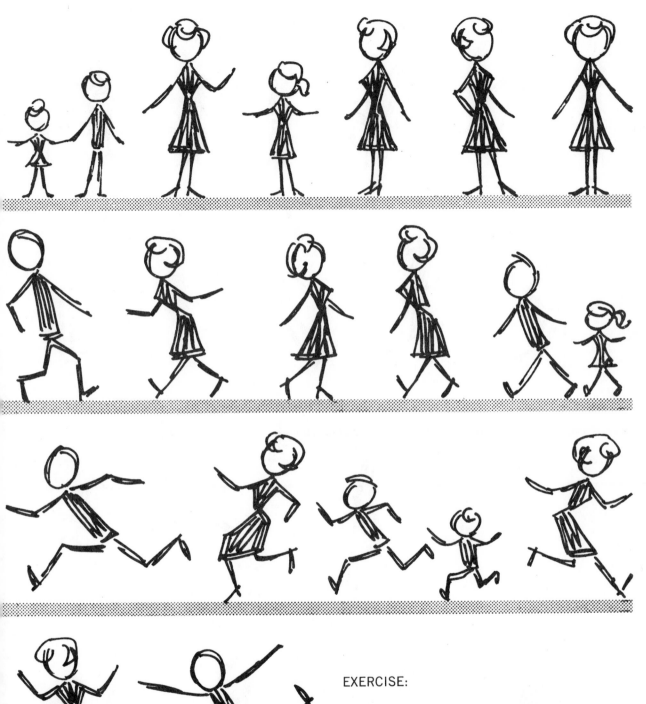

EXERCISE:

Notice the characteristics that define each of these four motions—specifically, the position of head, torso, arms, legs, feet. Then draw additional figures of men, women, and children standing, walking, etc., in positions different from those sketched above. Put varied emphasis upon speed or impact of motions.

GENERAL-PURPOSE MOTIONS

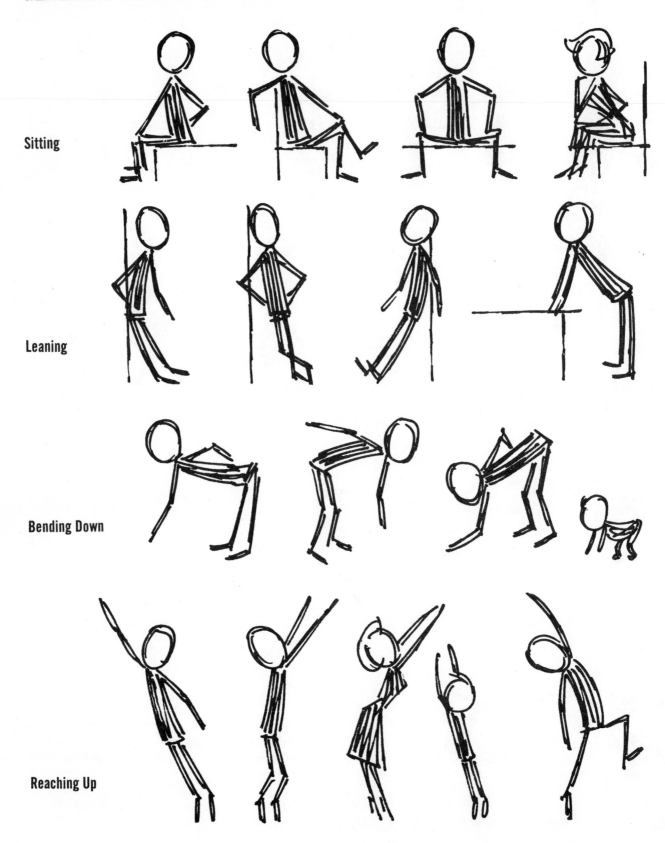

Sitting

Leaning

Bending Down

Reaching Up

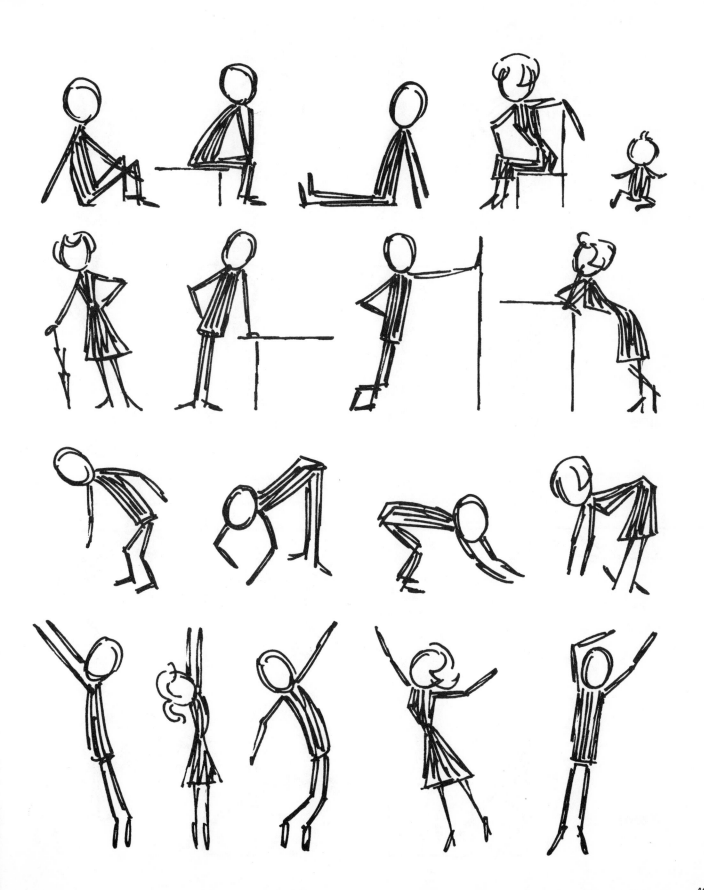

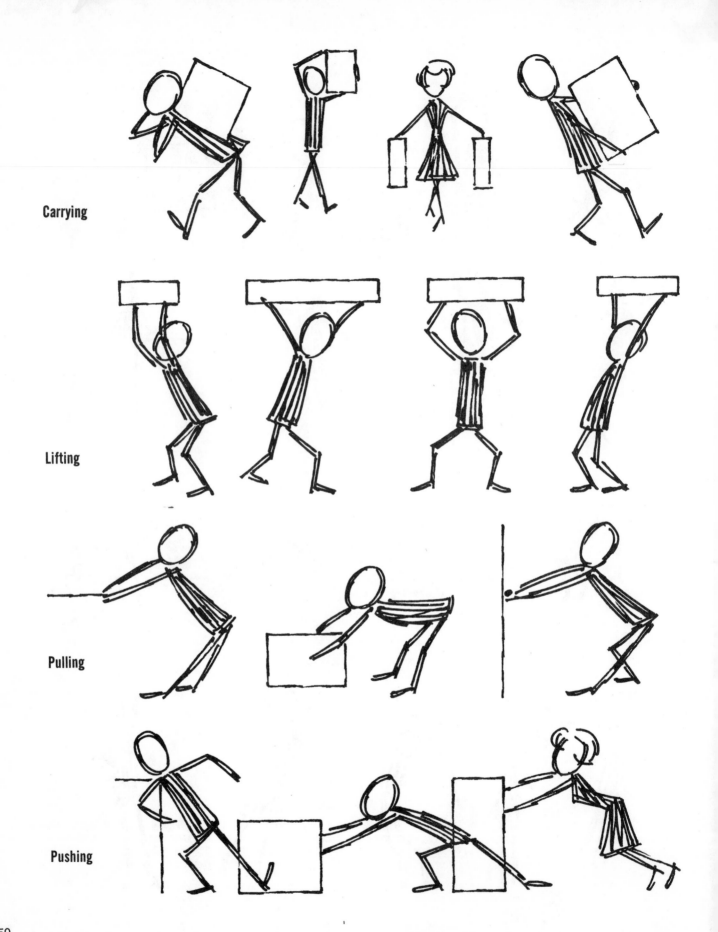

Carrying

Lifting

Pulling

Pushing

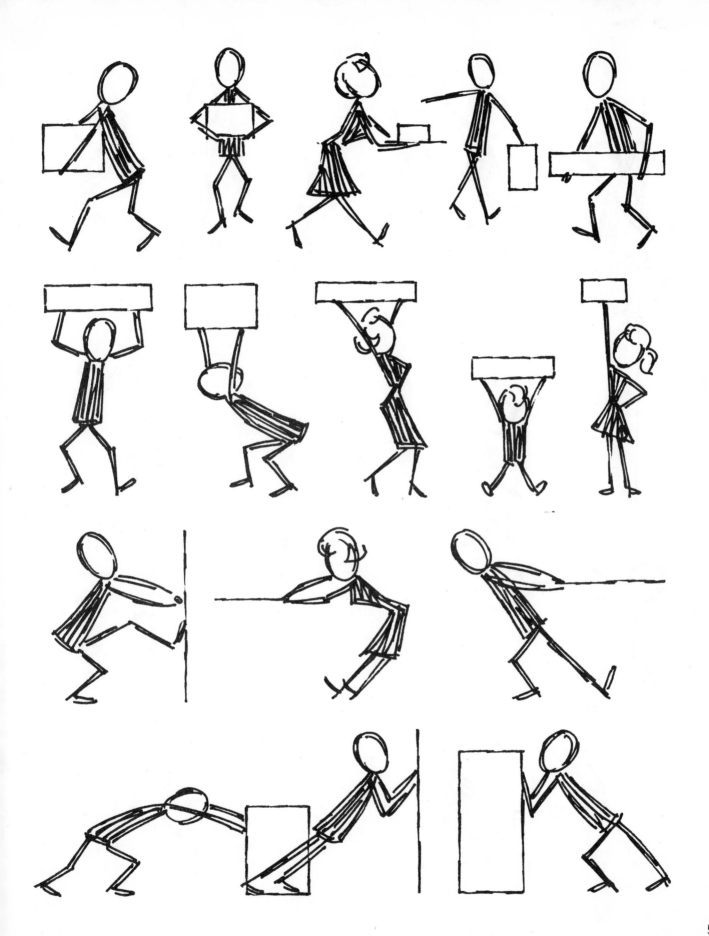

Climbing　　　　　　　　**Descending**

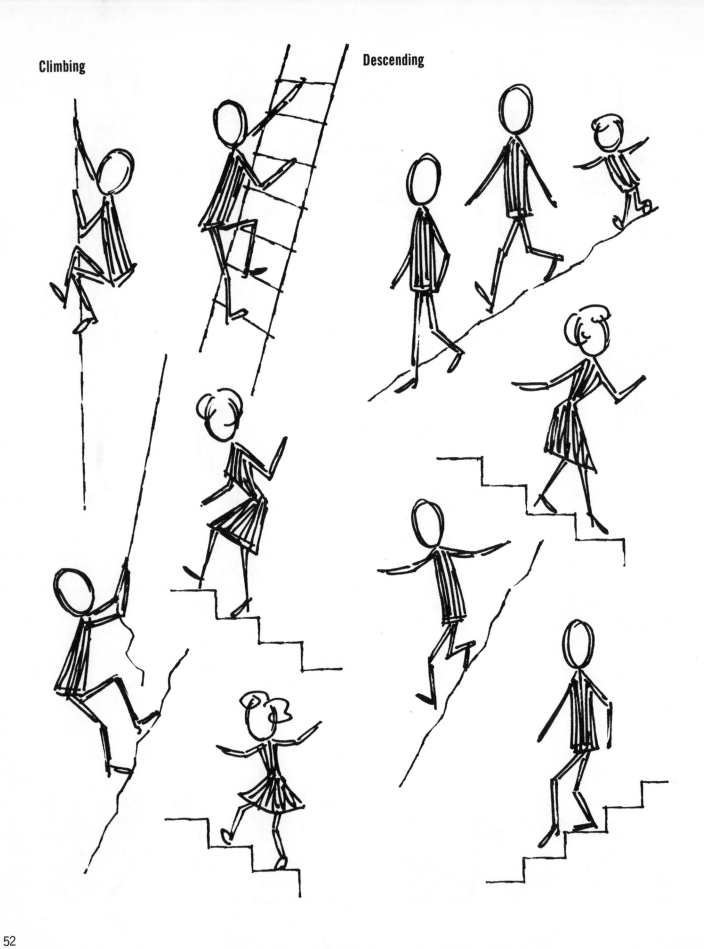

52

Resting

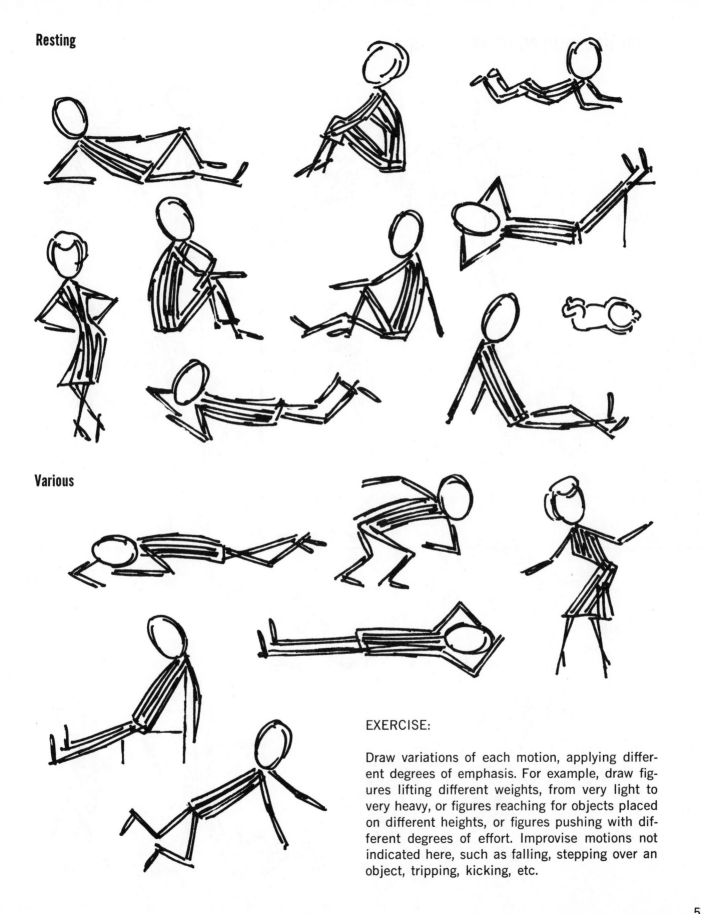

Various

EXERCISE:

Draw variations of each motion, applying different degrees of emphasis. For example, draw figures lifting different weights, from very light to very heavy, or figures reaching for objects placed on different heights, or figures pushing with different degrees of effort. Improvise motions not indicated here, such as falling, stepping over an object, tripping, kicking, etc.

SPECIFIC-PURPOSE MOTIONS

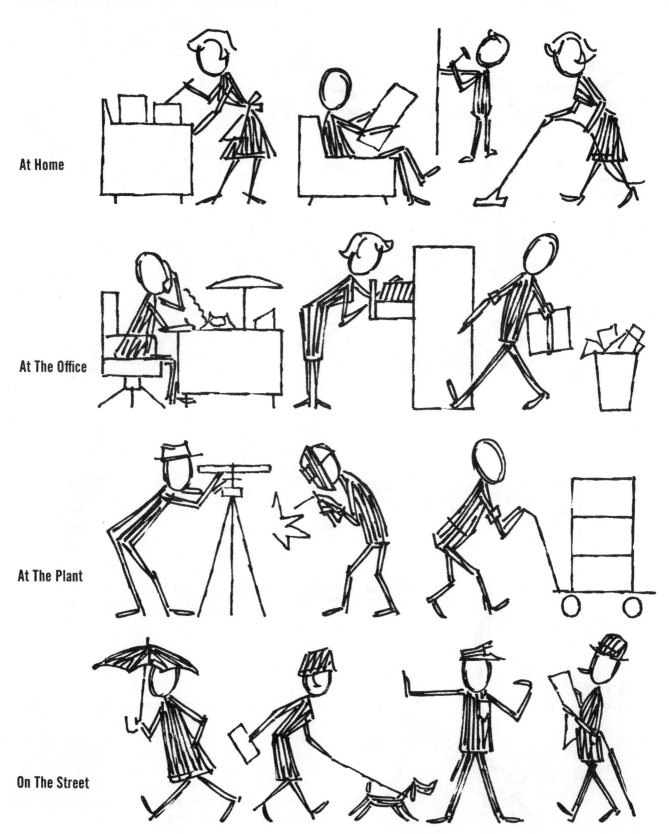

At Home

At The Office

At The Plant

On The Street

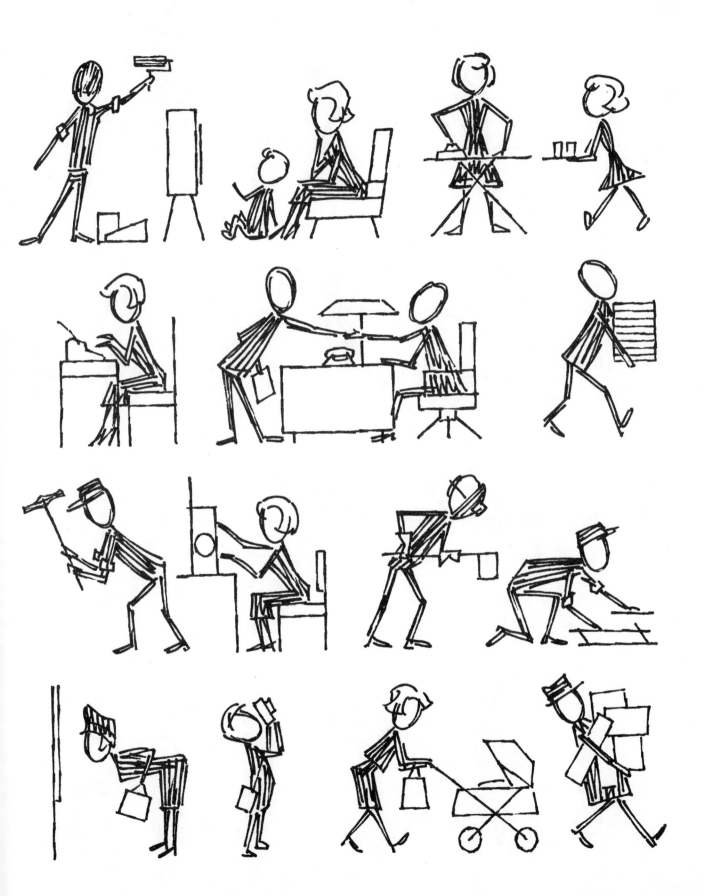

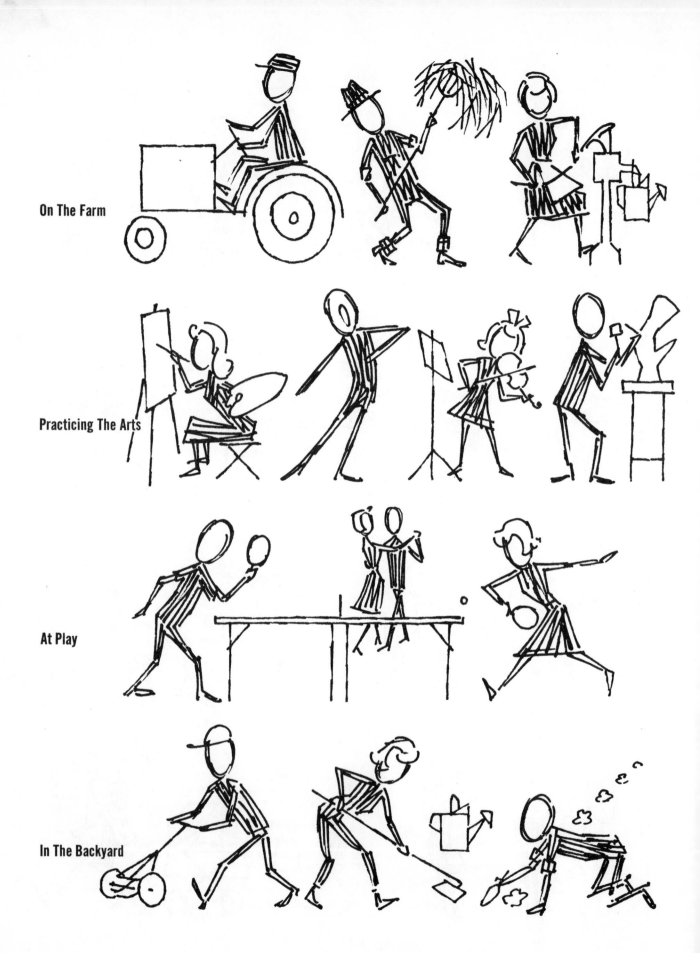

On The Farm

Practicing The Arts

At Play

In The Backyard

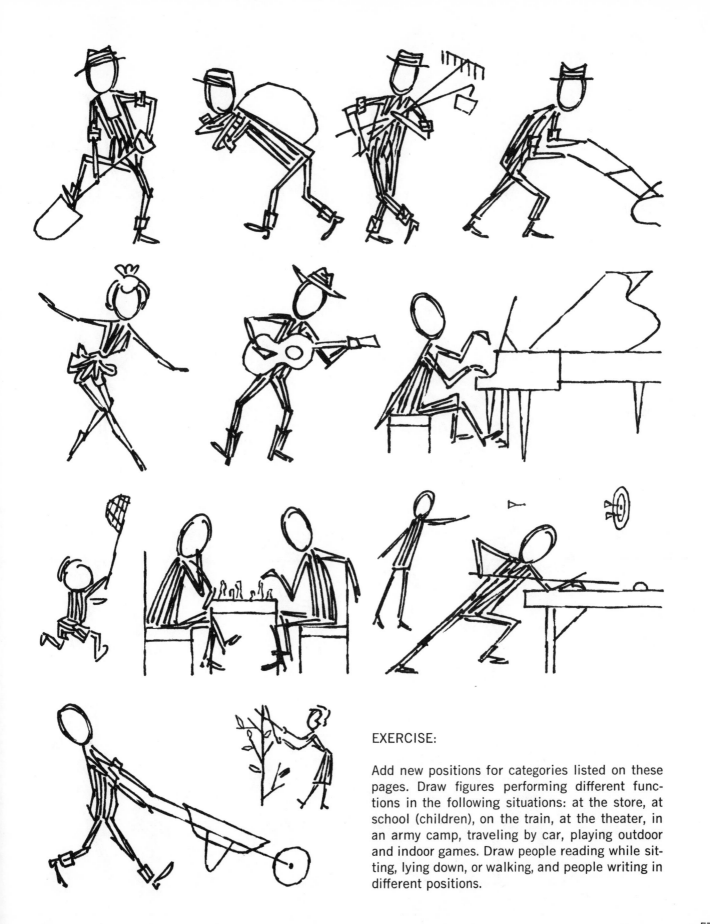

EXERCISE:

Add new positions for categories listed on these pages. Draw figures performing different functions in the following situations: at the store, at school (children), on the train, at the theater, in an army camp, traveling by car, playing outdoor and indoor games. Draw people reading while sitting, lying down, or walking, and people writing in different positions.

SPORTS MOTIONS

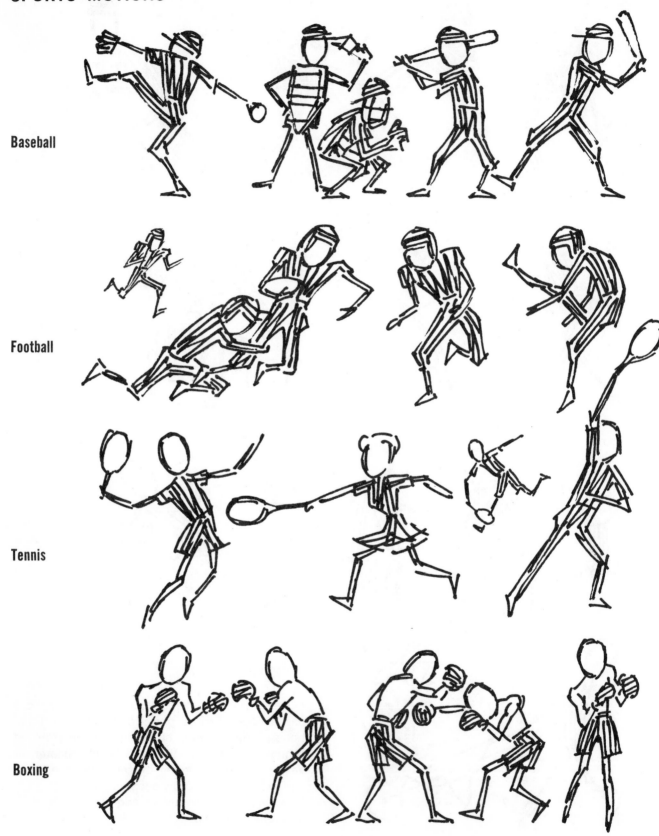

Baseball

Football

Tennis

Boxing

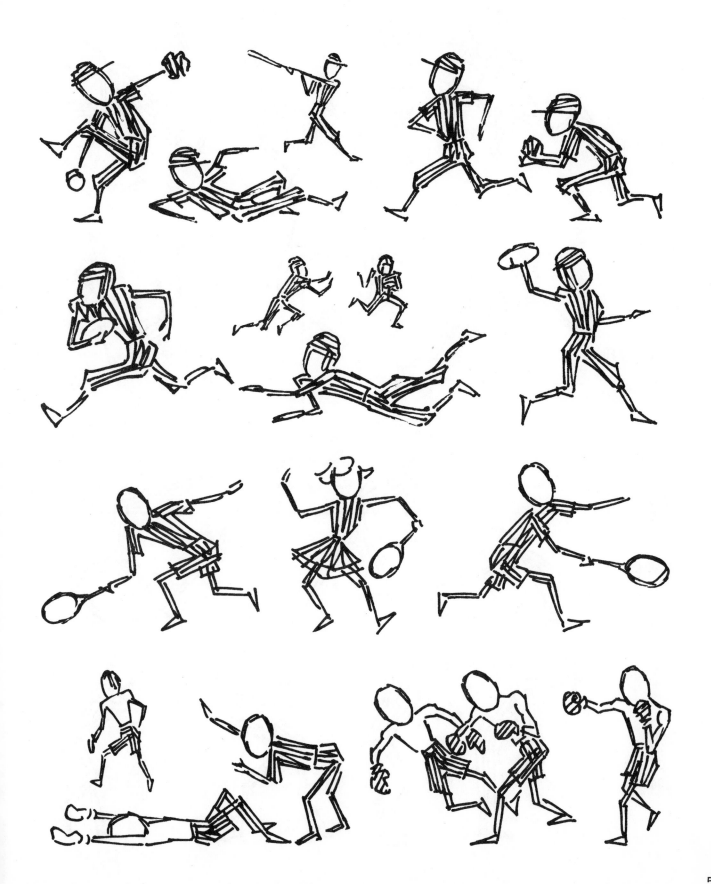

59

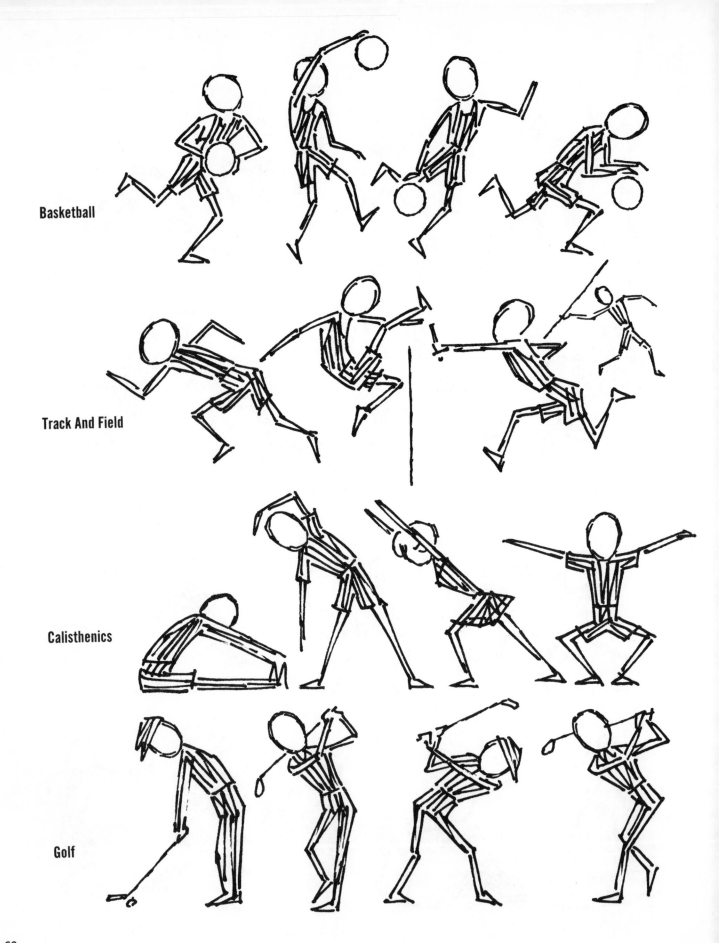

Basketball

Track And Field

Calisthenics

Golf

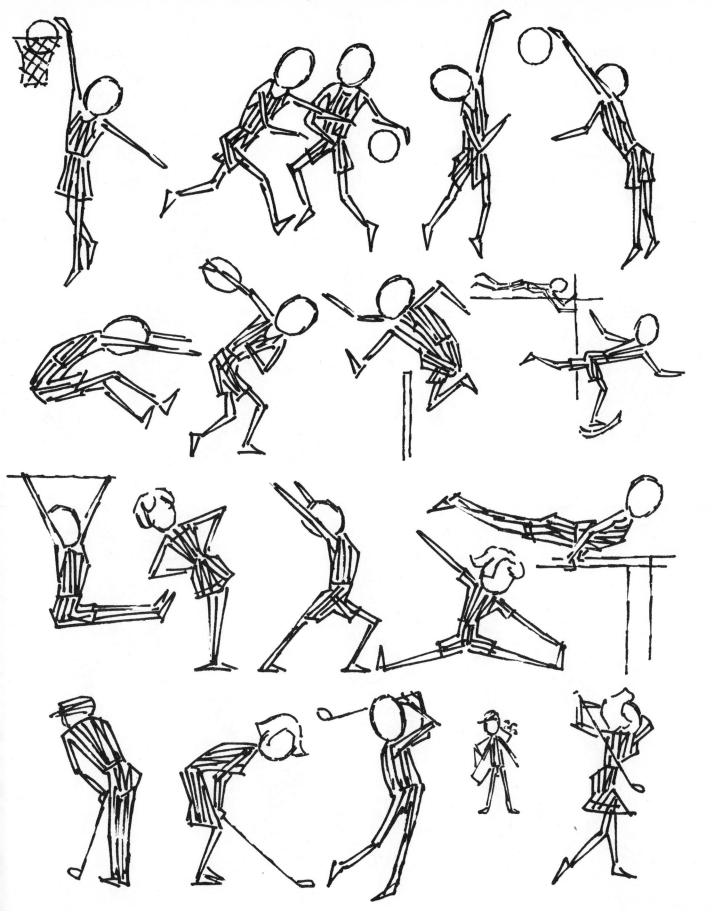

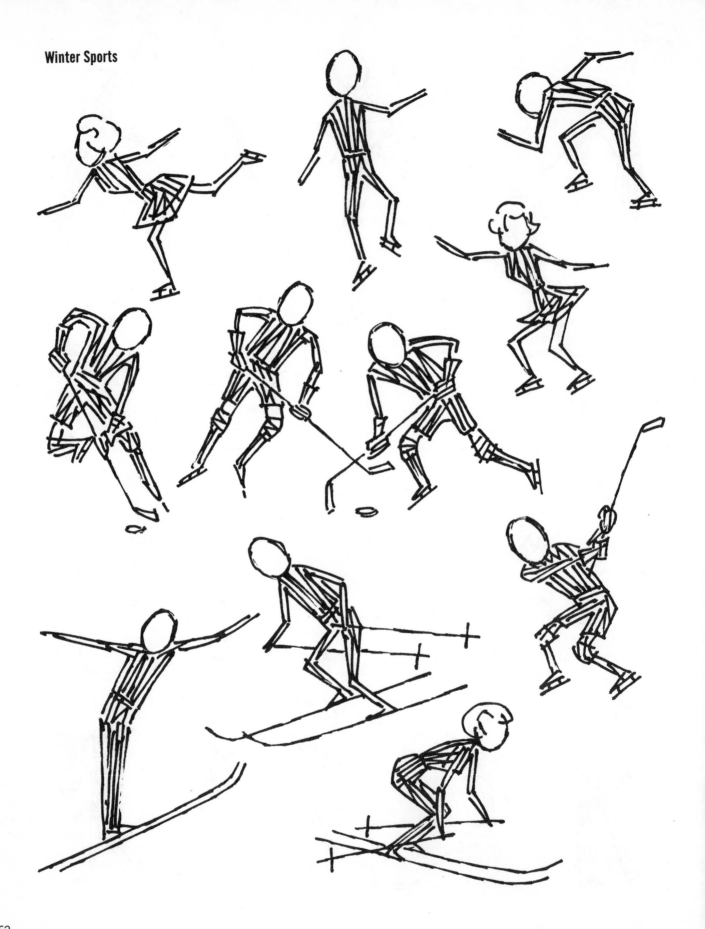

Fishing

Bowling

Hunting

Diving

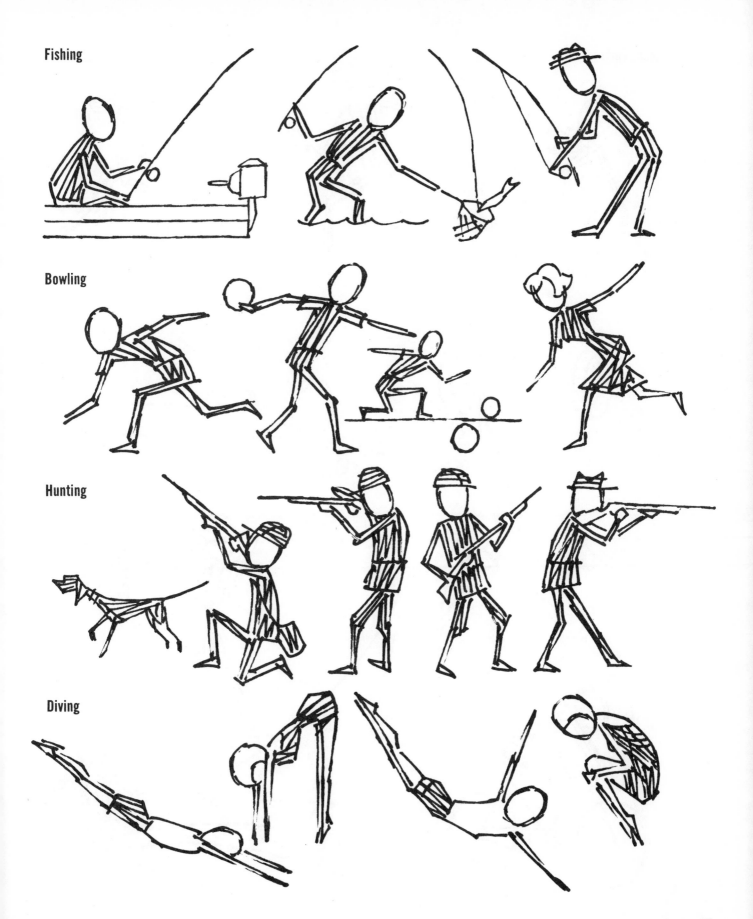

63

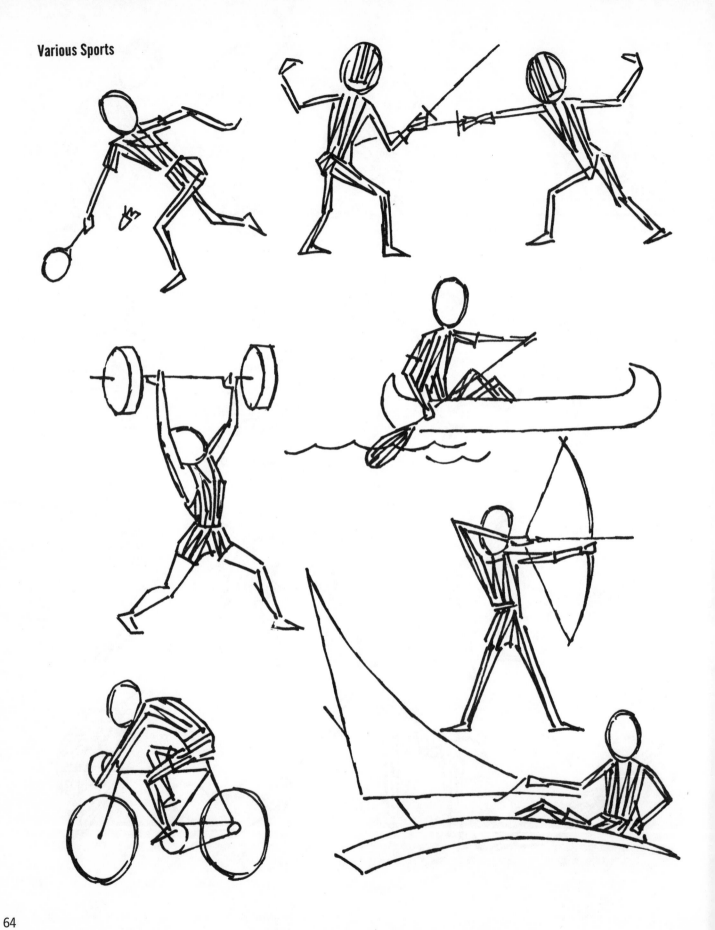

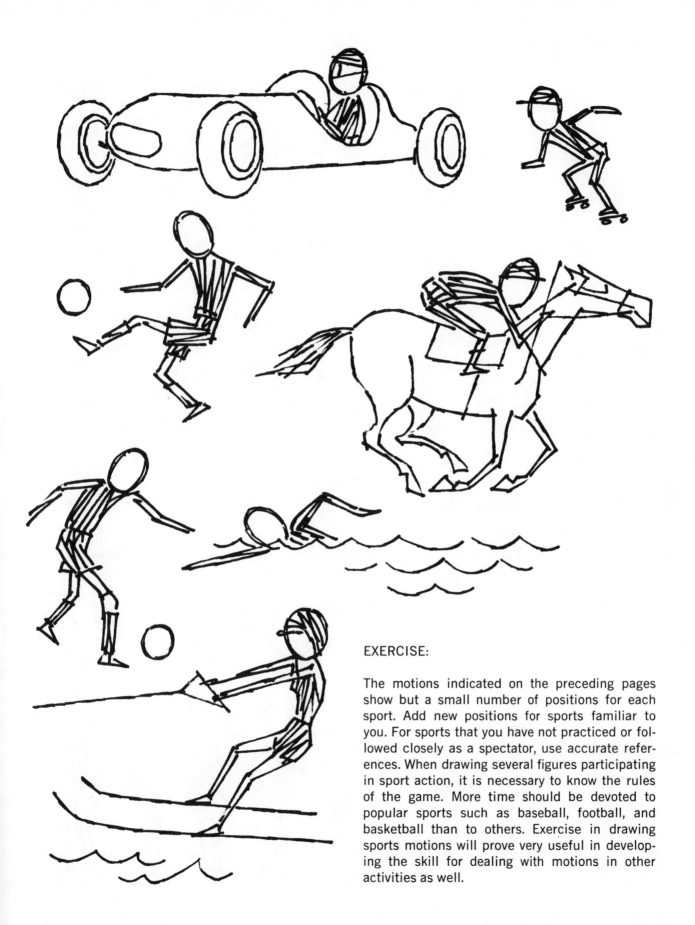

EXERCISE:

The motions indicated on the preceding pages show but a small number of positions for each sport. Add new positions for sports familiar to you. For sports that you have not practiced or followed closely as a spectator, use accurate references. When drawing several figures participating in sport action, it is necessary to know the rules of the game. More time should be devoted to popular sports such as baseball, football, and basketball than to others. Exercise in drawing sports motions will prove very useful in developing the skill for dealing with motions in other activities as well.

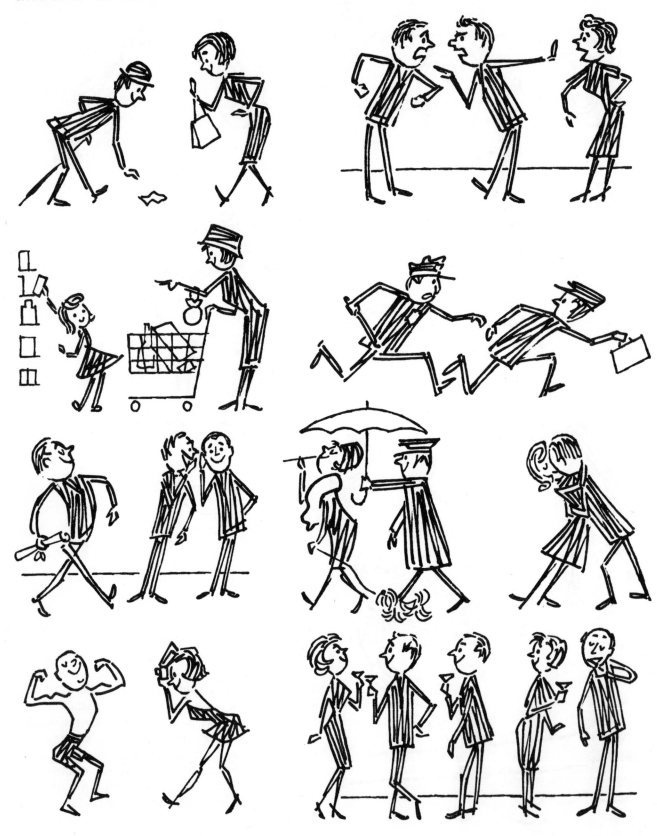

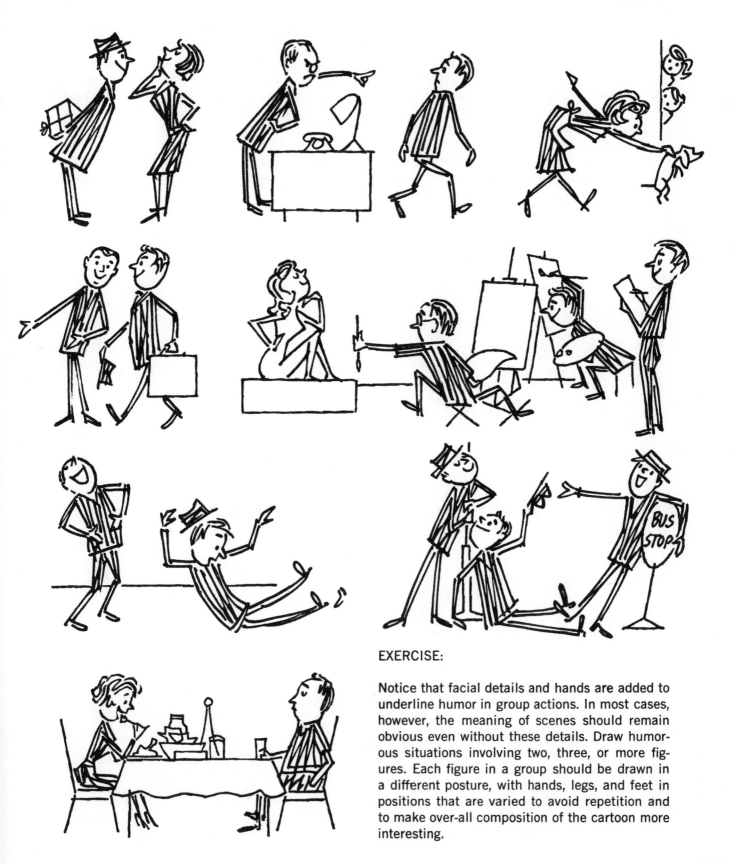

EXERCISE:

Notice that facial details and hands are added to underline humor in group actions. In most cases, however, the meaning of scenes should remain obvious even without these details. Draw humorous situations involving two, three, or more figures. Each figure in a group should be drawn in a different posture, with hands, legs, and feet in positions that are varied to avoid repetition and to make over-all composition of the cartoon more interesting.

ANIMALS

Two factors must be considered in humorous art dealing with animals: exaggeration and "humanization." Animals appearing in cartoons are almost invariably invested with human characteristics, or humanized. They bear facial expressions reminiscent of humans: they laugh, cry, speak, and express all their emotions in the manner of man. In cartooning, identical graphic symbolism is used to animate faces and figures of both men and animals: open mouth for laugh, frown or scowl for anger, etc.

Humorous exaggeration of animal features and proportions should be consistent with the anatomical peculiarities of the animal. An elephant can be drawn larger than normal and his trunk longer. A pig can be drawn fatter, a snake longer, the kangaroo's tail thicker.

Psychological characteristics attributed to animals should also be emphasized and exaggerated in humorous drawings. A fox should have a sly expression, an ostrich may look stupid, a rhinoceros ferocious, and so on.

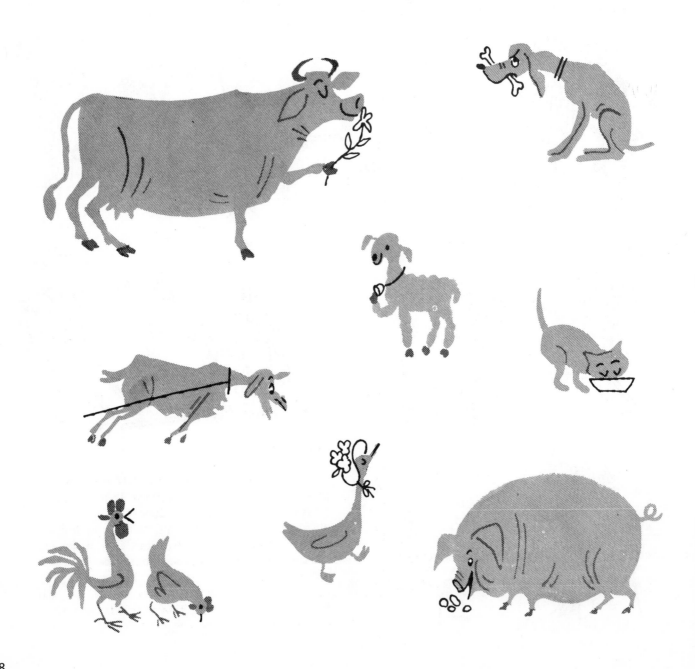

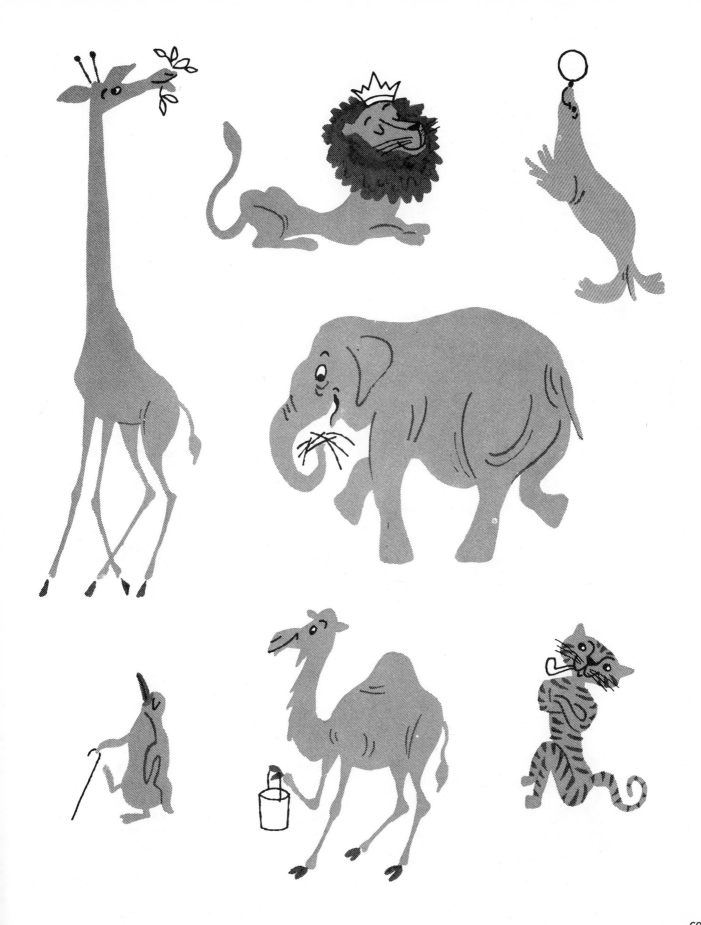

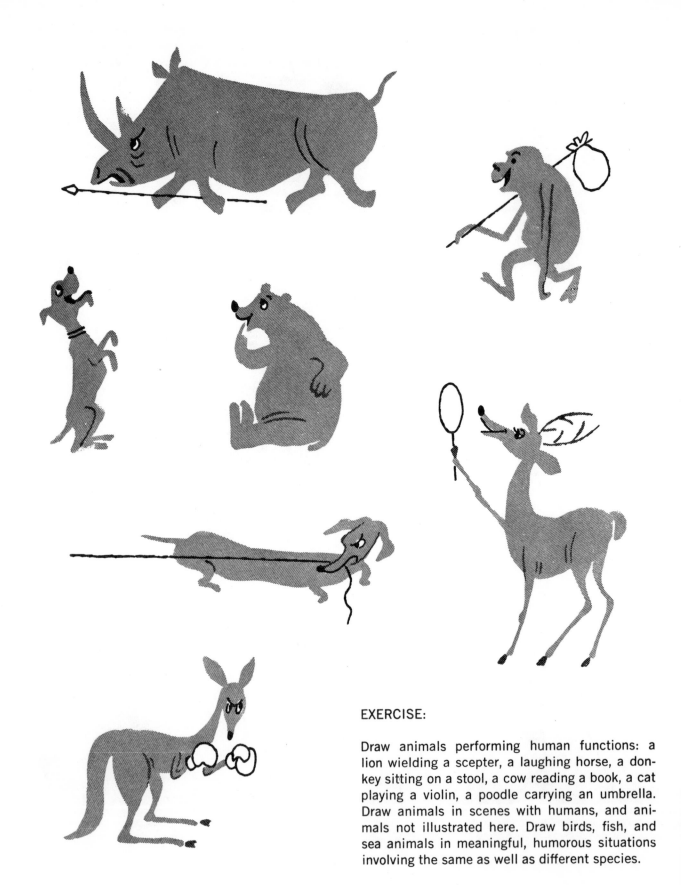

EXERCISE:

Draw animals performing human functions: a lion wielding a scepter, a laughing horse, a donkey sitting on a stool, a cow reading a book, a cat playing a violin, a poodle carrying an umbrella. Draw animals in scenes with humans, and animals not illustrated here. Draw birds, fish, and sea animals in meaningful, humorous situations involving the same as well as different species.

ANIMATED OBJECTS

Cartoon animation of objects follows the same humanization as animation of animals. The objects are provided with faces, legs, and arms, and imitate human actions.

Advertising and children's book illustration are two major fields that use animated-object drawings. In advertising, the animation is usually achieved in such a way as to preserve intact the identity of the package or product. When head and limbs are added, they are drawn in a manner that allows the character of the object to remain unchanged. They may be drawn on the outside of the object area or on its surface, but the brand name, the trademark, and the label characteristics should be left unobstructed or easily legible. When the form of the object itself is bent into some action, the distortion should be believable.

In children's books, animation of objects allows considerable distortions to suit action and expression. Objects can be simplified and details omitted to make the animation clearer. The object may be twisted, elongated, shortened, corrugated, etc., according to need.

When animating objects, artists may use auxiliary graphic effects to emphasize action. In the drawings on the next page the Dutchman smoking a pipe, the running bottle, and the ringing alarm clock show how these effects may be used. But where there is no commanding need, they should be avoided, to preserve simplicity and clarity of design.

In animation of objects, gender also must be considered. "She" objects, like the ship, should bear appropriate feminine characteristics; the sex of "it" objects may vary according to circumstances, the artist's judgment, or accepted rules.

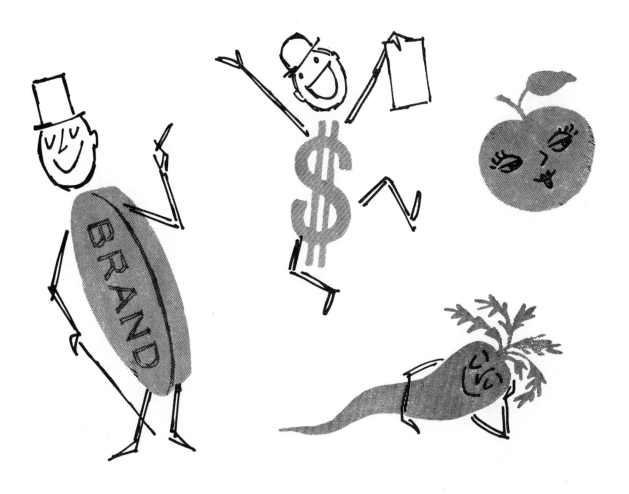

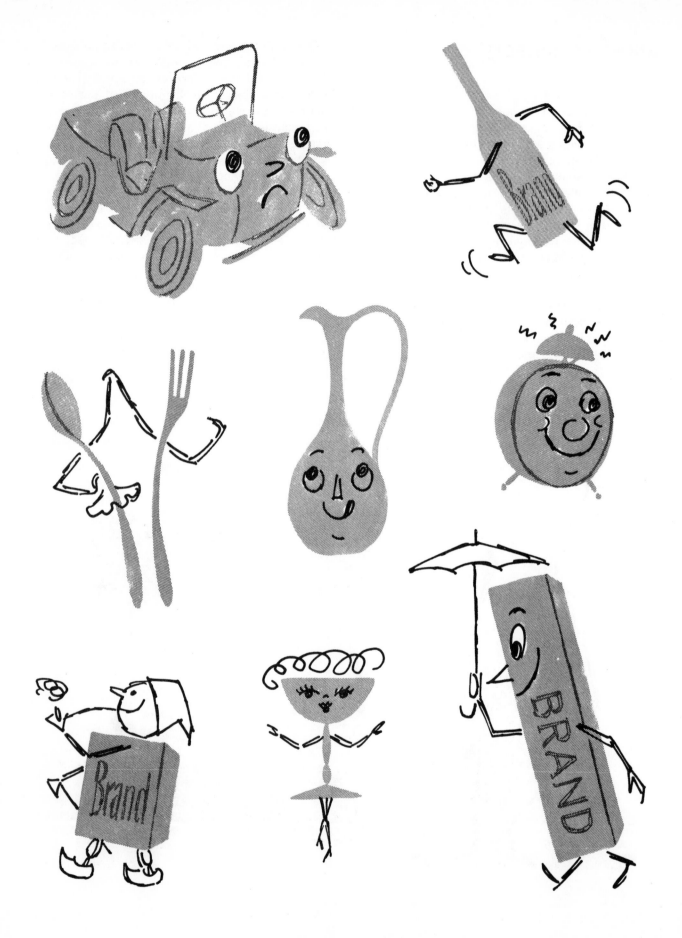

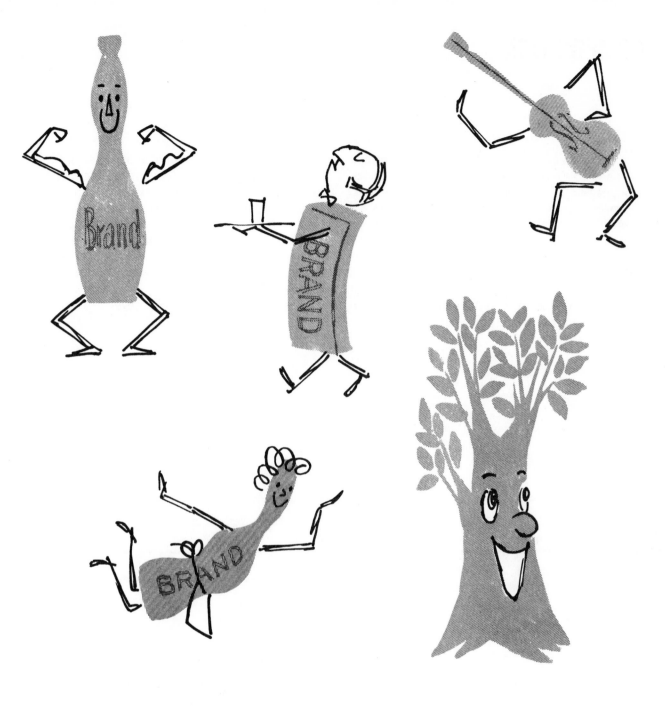

EXERCISE:

Prepare a list of objects for cartoon animation. Work on one item at a time, trying to find as many ways of animating as you can. Here are some suggestions of objects in animated situations: smiling flower, angry book, proud cello, happy sailboat, shivering automobile, dancing banana, jumping box, laughing star, happy house, flying kettle.

COMPOSITION

There are many structural and aesthetic principles and methods that can guide an artist in the composition of his picture. All these methods, geometric or not, aim at the same purpose: achieving an integrated whole by combining, grouping, or arranging different elements in the picture. The resulting effect is called "harmony" or "beauty." Neither "harmony" nor "beauty" has a precise, clearly defined meaning, and the door is always wide open for artists' individual interpretation of problems of composition.

In the work of a commercial artist, sound composition involves the logical and practical factors of function and emphasis as well as the ideal factors of harmony and beauty. Eventually, every artist should arrive at his own method of applying his own sense of purpose and design. However, it is possible to suggest a usable, elementary method to be followed by the artist in building a "correct" composition.

The study below shows several successive steps that can be followed.

1.

Start by tracing in pencil the rectangular outline of the area within which the picture is to be contained. Draw a horizon line across the rectangle. This line should run off center to avoid symmetry.

2.

Draw a perpendicular line to determine the position of the leading foreground motif. This line should also be drawn off center. At this point decide whether the motif should be placed on the right or the left side of the picture, and trace the perpendicular line accordingly. The horizon line and the motif line constitute the backbone of your composition.

3.

Sketch roughly and without details the items that should be present in your picture. Begin with the leading motif (man pushing wheelbarrow), then sketch the background elements (tree and cloud), which should be subordinated in size and position to an unobtrusive arrangement in relation to the motif.

4.

Outline the area of your composition with an imaginative, freely flowing line that will touch each side of the rectangle at a single point. The four points, when joined, should form an asymmetrical quadrangle that is well balanced within the picture space. The flowing line determines approximately the over-all shape of your composition, its basic structure, its originality and attractiveness. Diversity of bulges and wells add interest. When shaping the curve, avoid obvious symmetry and excessive repetition of forms.

5.

Check the balance of the curve within the rectangle. Adjust and correct the drawing in relation to the curve, and vice versa. If you find it necessary to add some details (leaves on the ground), in order to improve your composition, these details should contribute to the idea in your illustration, not detract from it.

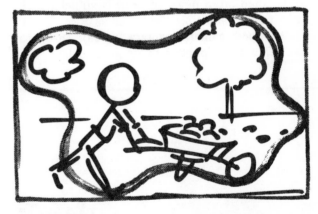

6.

The finished composition should have some continuity in design. An imaginary line traced through all the principal elements in the picture should stand by itself as a good design. It should be well balanced inside the rectangle and inside the curve, and as a design it should have a certain rhythm and beauty.

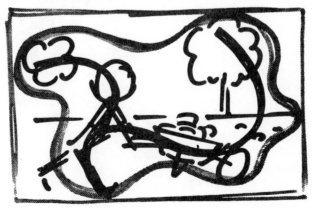

SCALING IN PROPORTION

The most frequent scale of finished art is ½ or ¼ larger than the reproduction size. However, should the artist feel more at ease preparing finished art in the actual reproduction size, in most instances he will be allowed to do it this way. Art work is rarely executed in reduced size for enlargement in reproduction.

There are three mechanical methods for scaling (enlarging or reducing) sketches or layouts to the desired dimensions while preserving true proportions:

1. **Photostats,** or **"stats."** A sheet of tracing paper bearing instructions should be taped over the art work to be photostated. The desired critical dimension (either height or width), the kind of photographic paper (glossy or matte), and the required number of negative or positive prints should be marked clearly on the tracing. When a stat is used merely as a guide in the preparation of finished art, a negative print is sufficient. The minimum over-all size of a stat is 8½″ × 11″.

2. **"Luci" camera (camera lucida).** This is an instrument equipped with prism and lenses for visual (not photographic) enlarging or reducing. Sketches, layouts, or reference items to be projected are tacked on a brightly lighted copy board facing the luci and the artist traces their image projected on the drawing table while he looks through the prism. The distance between the camera and the copy board determines the size of the projected image. A model of a luci camera is illustrated below.

3. **Camera projectors.** These cabinet-type projectors are used mostly by art studios, but many ingenious artists devise and construct their own projectors. Projection of material is achieved by a system of mirrors.

A fourth method used for proportional scaling of art work is the geometric "hand" method, which can be applied when other three are not available or not desirable.

In order to clarify explanation of this method, the process of scaling, shown on the opposite page, has been divided into six stages. However, workable procedure requires that only one sketch be made when a drawing is enlarged or reduced.

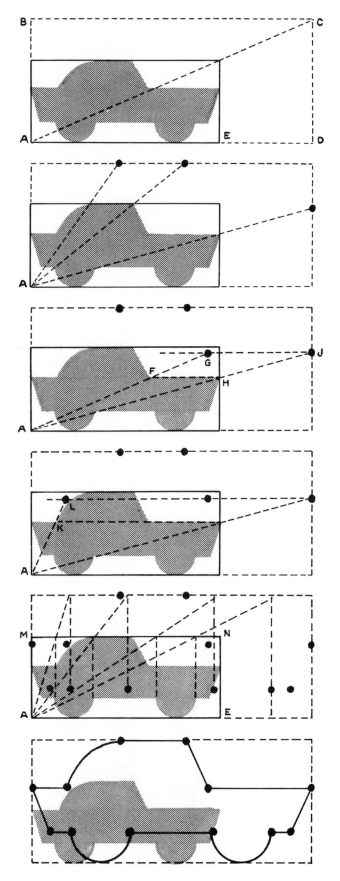

Draw a rectangle through the extremities of the car, and a diagonal line AC. AE is the original width of the car, and AD is the desired width ("half-up" the original size). Rectangle ABCD represents proportional half-up enlargement of the original rectangle.

Draw lines from A through points of car touching the insides of the original rectangle. Place dots where these lines touch the rescaled rectangle. These three dots represent the first points on the outline of the enlarged car.

Study this step carefully. The method by which point F is proportionately transferred to G will be followed for all other points. Draw line from A passing through F, then a horizontal line FH. Now draw AH, and continue this line till it meets the large rectangle at J. From J draw another horizontal line which will meet continued AF at point G. G is rescaled point F.

By following the same procedure, point K is transferred to L.

After several other points have been transferred defining the outlines of car, only the wheels remain to be transferred. The same method is applied, but horizontal line MN is used instead of vertical line EN which was used previously.

Proportionately rescaled drawing of car emerges when all the established points are connected. It is a half-up enlargement of the original drawing.

As an exercise, follow the same method in reverse to rescale a drawing to reduced size.

PERSPECTIVE

No matter how great the extent of nonrealism or interpretation in a humorous drawing, some elementary rules of perspective should be applied to make the drawing believable. Artists who are inclined toward more realistic styles should acquire much more extensive knowledge of perspective than that which they might learn from the following "short cuts." Understanding of the basic rules of perspective will prove especially useful in drawing such backgrounds as streets, roads, buildings, landscapes, and interiors.

In some cases, the relative sizes of figures and objects, if drawn correctly, will explain action and humorous idea. In other cases, when exaggeration of sizes and proportions is desirable in order to stress some humorous point, knowledge of perspective is helpful again, for it may make

"correct" exaggeration possible.

Only a few elementary perspective drawing problems are presented here.

Anything drawn by cartoonists is related to a **horizon** and to **vanishing points.** The horizon line, whether drawn or merely imagined, runs horizontally across every picture. Regardless of the position from which a picture is seen (faced directly, from the sides, from above, or from below), the horizon remains at **eye level.** The place from which the artist sees the picture is called the **station point.** The imaginary window opening on the space he provides for his drawing is called the **picture plane.** Parallel lines extended from any object in the picture (except for lines parallel to the picture plane) meet on the horizon at a vanishing point.

Placing the object or figure in a block is the first step in perspective drawing. Each of the six sides of the block must touch the subject being drawn in perspective. The drawing of the duck as it fits into the block indicates all points of contact—A, B, C, D, and E. Point D is actually hidden from our sight by the duck's body.

If the block is drawn correctly in perspective, the object contained in the block can be drawn accurately. To draw a block in perspective, begin by sketching it free-hand in approximately the position in which you wish the block to appear in your picture. The block lies flat on the ground.

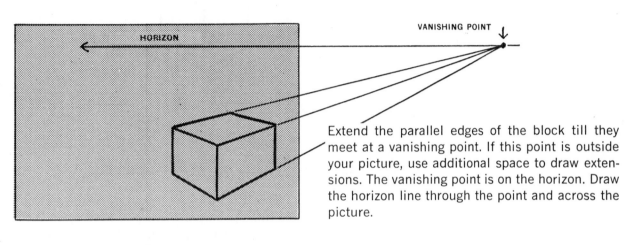

Extend the parallel edges of the block till they meet at a vanishing point. If this point is outside your picture, use additional space to draw extensions. The vanishing point is on the horizon. Draw the horizon line through the point and across the picture.

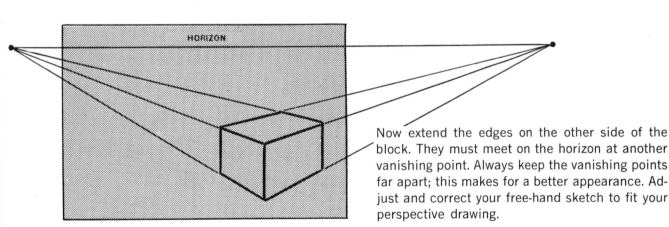

Now extend the edges on the other side of the block. They must meet on the horizon at another vanishing point. Always keep the vanishing points far apart; this makes for a better appearance. Adjust and correct your free-hand sketch to fit your perspective drawing.

As an exercise, add several more blocks of different types, and place them on the ground in different positions. Each block will have its own pair of vanishing points on the same horizon. Perpendicular lines of blocks do not meet.

ONE- TWO- AND THREE-POINT PERSPECTIVE

1. Single-point perspective, in which the base line of the block is parallel to the horizon. The block is at right angles to the line of vision, and it has only one vanishing point, A.

2. Two-point perspective, in which the block is drawn at an oblique angle in relation to the horizon. Since two of the block's vertical sides are visible, there are two vanishing points, B and C.

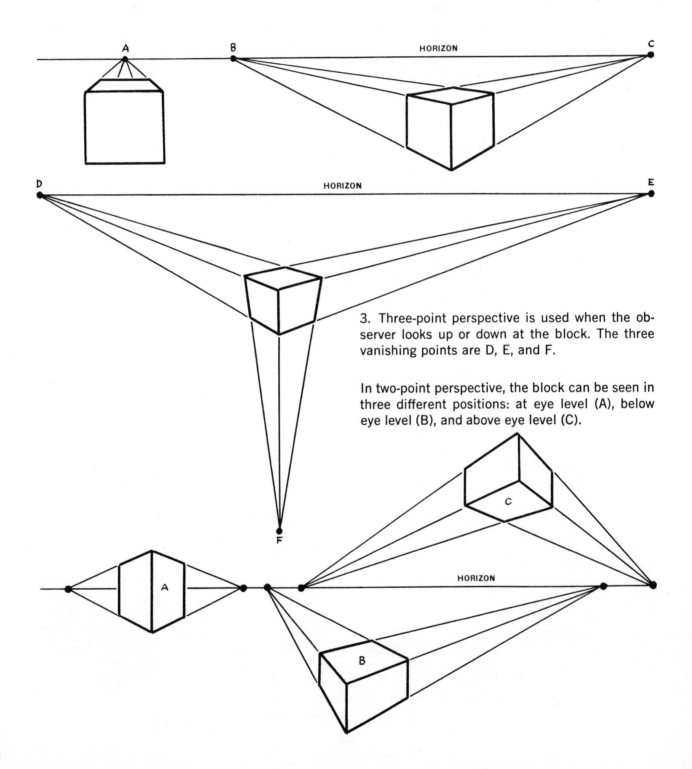

3. Three-point perspective is used when the observer looks up or down at the block. The three vanishing points are D, E, and F.

In two-point perspective, the block can be seen in three different positions: at eye level (A), below eye level (B), and above eye level (C).

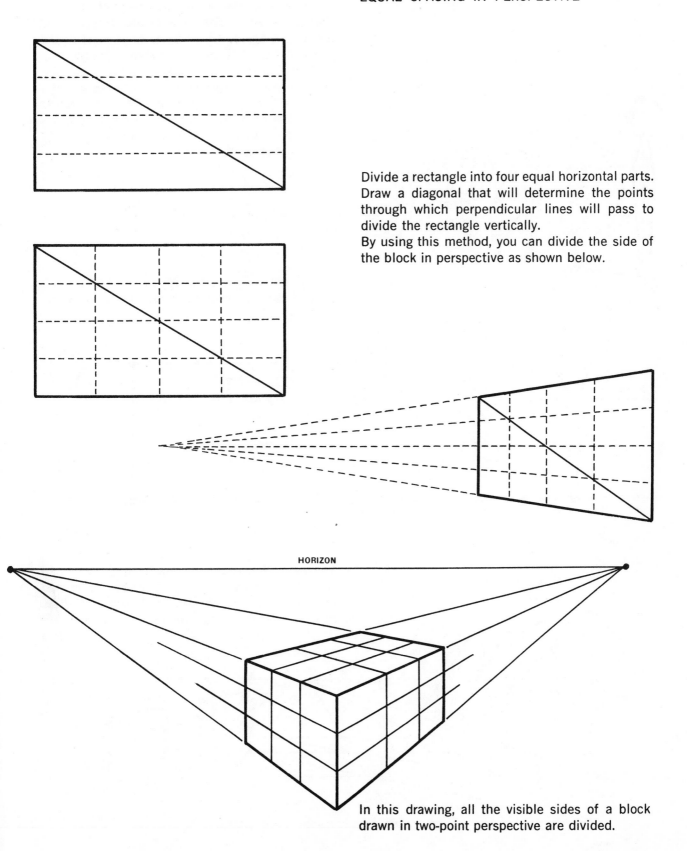

EQUAL SPACING IN PERSPECTIVE

Divide a rectangle into four equal horizontal parts. Draw a diagonal that will determine the points through which perpendicular lines will pass to divide the rectangle vertically.

By using this method, you can divide the side of the block in perspective as shown below.

HORIZON

In this drawing, all the visible sides of a block drawn in two-point perspective are divided.

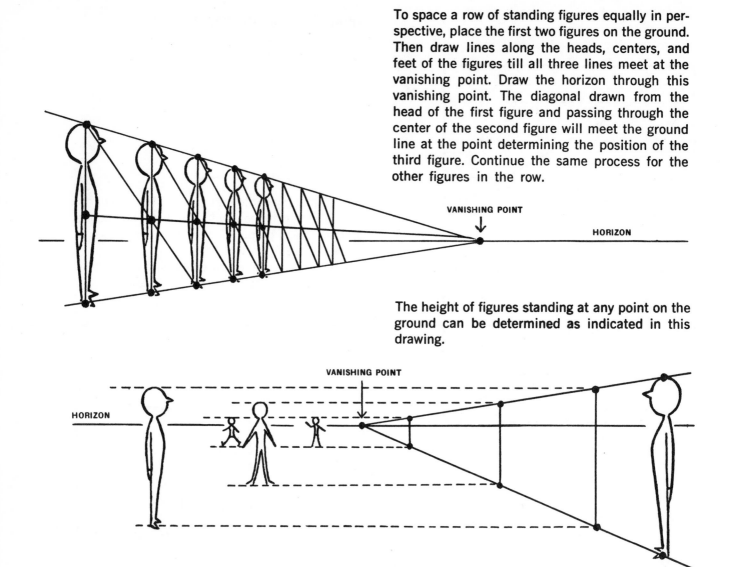

To space a row of standing figures equally in perspective, place the first two figures on the ground. Then draw lines along the heads, centers, and feet of the figures till all three lines meet at the vanishing point. Draw the horizon through this vanishing point. The diagonal drawn from the head of the first figure and passing through the center of the second figure will meet the ground line at the point determining the position of the third figure. Continue the same process for the other figures in the row.

VANISHING POINT

HORIZON

The height of figures standing at any point on the ground can be determined as indicated in this drawing.

VANISHING POINT

HORIZON

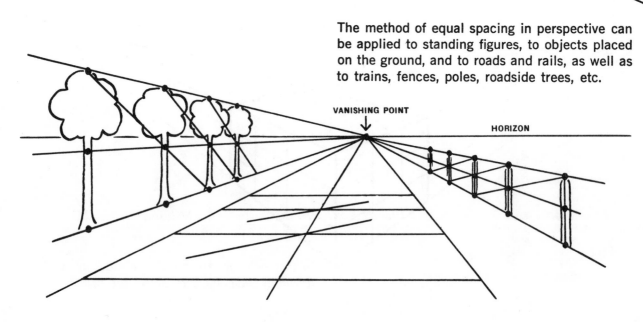

The method of equal spacing in perspective can be applied to standing figures, to objects placed on the ground, and to roads and rails, as well as to trains, fences, poles, roadside trees, etc.

VANISHING POINT

HORIZON

This drawing explains how to find centers A and B of the rectangular sides of a house, how to draw the slope of the roof in perspective, and how to place the chimney in the center of the roof.

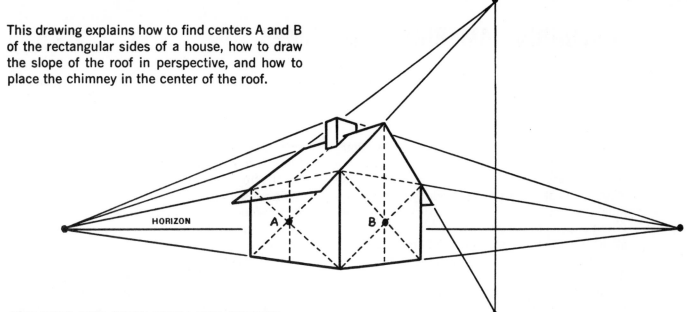

BUILDING THE CUBE FROM THE SQUARE

Draw the square ABCD, at any chosen angle, and picture plane EF. Drop a vertical line from A to the station point, which is your viewing position. Points E and F are found by drawing, from the station point, two lines parallel to the sides AB and AD of the square. Now draw a ground line above your station point. Drop points E and F to establish vanishing points on the horizon, which is drawn anywhere between the picture plane and the ground line. Points A, B, and D aim at the station point. Finally, drop points G and H to base lines, and proceed to build the cube in perspective as indicated on the drawing.

DRAWING THE ELLIPSE FROM THE CIRCLE

The circle fits into the square. By dividing the square (the side of the cube in this drawing) as shown, you can draw the ellipse (the circle in perspective) correctly.

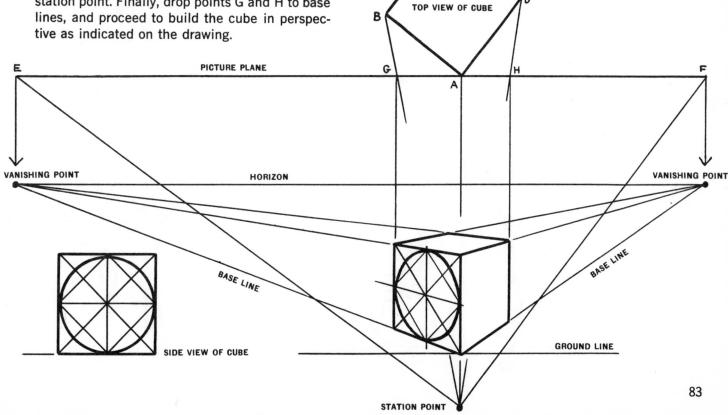

HISTORICAL AMERICAN COSTUMES

Men's, children's, and especially women's clothing change frequently and drastically from season to season and from year to year. These changes must be observed carefully and applied judiciously. Different cartoon styles require different degrees of fashion awareness, but all styles must bear at least some influence of up-to-date fashions if they are to project a modern flavor.

Because of the instability and great diversity of designs in fashion, it seems precarious to indicate here the clothing of the present day. Students should avail themselves of recent fashion clippings and use them as references for their exercises.

Historic costumes are used frequently in cartoons and humorous illustrations. When the authenticity of a historical period is important, artists should base their drawings on accurate reference material. In many instances, however, just a few typical costume details extracted wisely from complete references will suffice to define a period.

The following sketches, drawn for this book by the fashion artist Diane Petersen, show some examples of American historic costumes from several outstanding costume eras. Diane has done important work for leading department stores and manufacturers in America. Her illustrations have appeared in such magazines as "Harpers Bazaar," "Town & Country," "Ladies Home Journal," "Good Housekeeping," "Vogue," "Glamour," "Mademoiselle," and others. By using a Japanese pen and India ink on grained-water color paper, Diane obtains masterful drawing effects while preserving authenticity of detail.

It could be of interest to some artists to study the Japanese pen technique for use in cartooning.

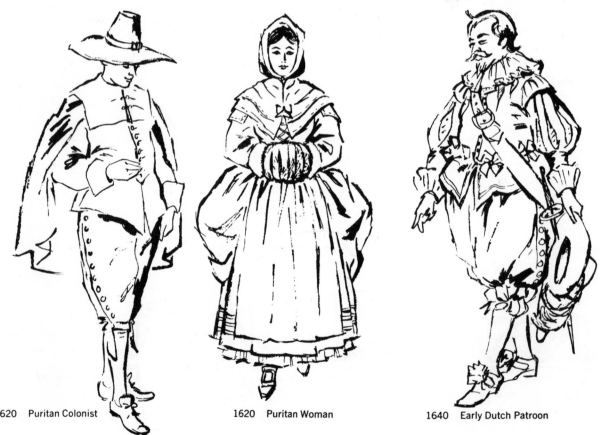

1620 Puritan Colonist 1620 Puritan Woman 1640 Early Dutch Patroon

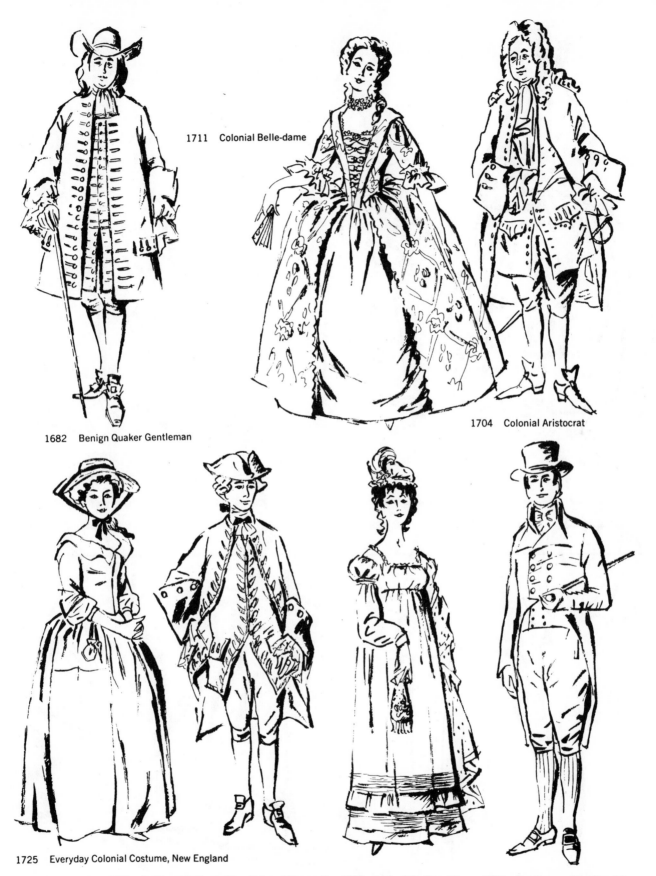

1711 Colonial Belle-dame

1682 Benign Quaker Gentleman

1704 Colonial Aristocrat

1725 Everyday Colonial Costume, New England

1740 Fashionable Young Man, Reign of George II 1797 Lady of the Republic 1800 Gentleman of the Republic

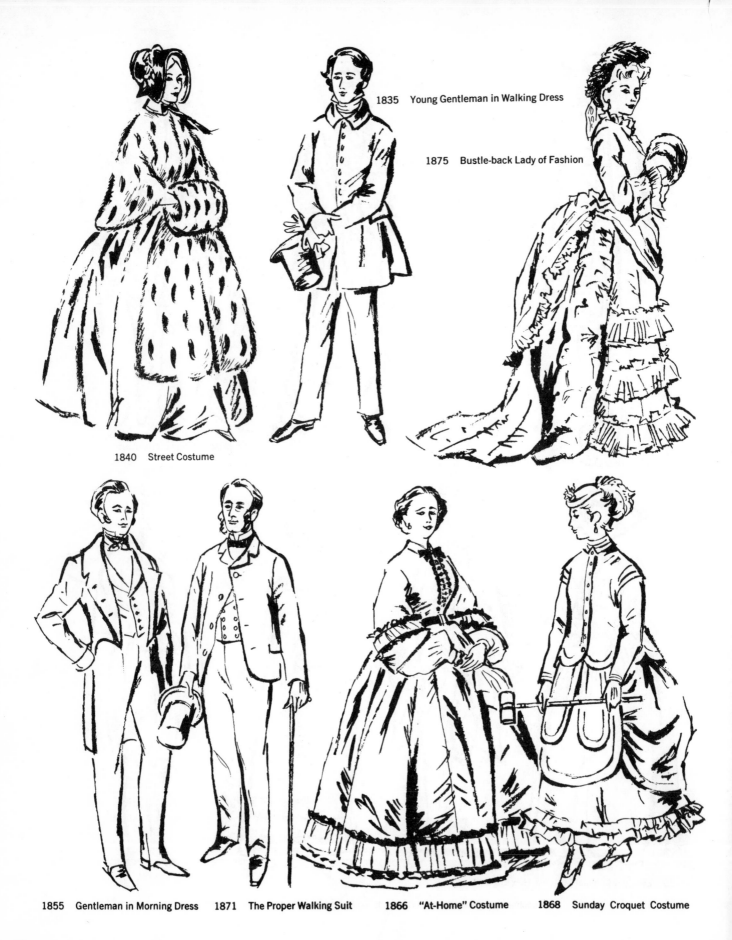

1835 Young Gentleman in Walking Dress

1875 Bustle-back Lady of Fashion

1840 Street Costume

1855 Gentleman in Morning Dress 1871 The Proper Walking Suit 1866 "At-Home" Costume 1868 Sunday Croquet Costume

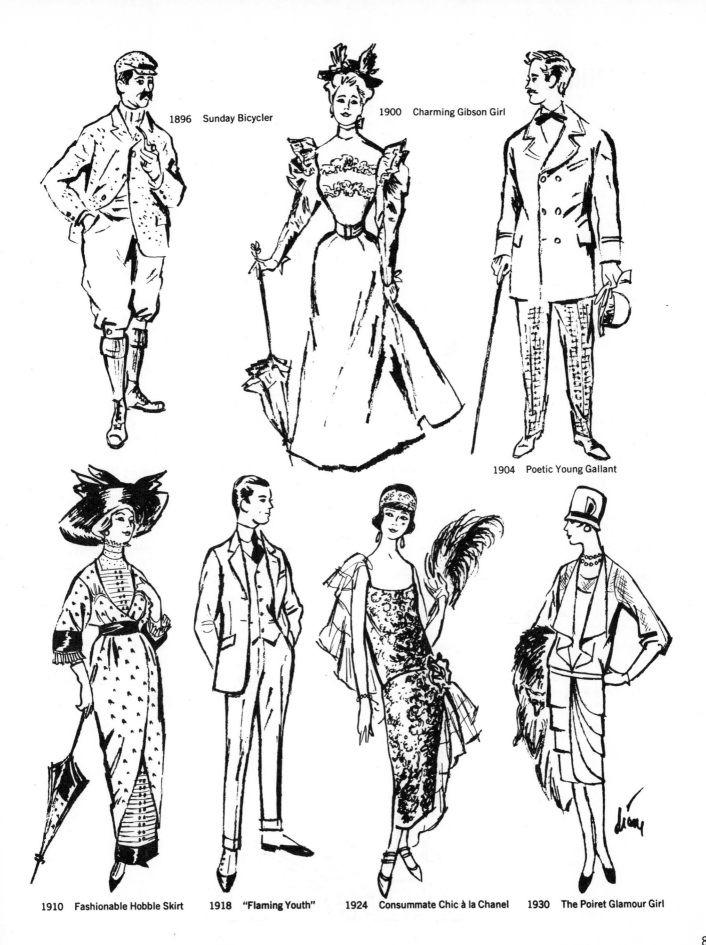

1896 Sunday Bicycler

1900 Charming Gibson Girl

1904 Poetic Young Gallant

1910 Fashionable Hobble Skirt

1918 "Flaming Youth"

1924 Consummate Chic à la Chanel

1930 The Poiret Glamour Girl

CARTOON STYLES

The only common denominator for a multitude of existing cartoon styles is humor. The techniques and media used by cartoonists vary as much as the mood, wit, and intensity of humor in their drawings.

Classification of a style in a definite cartoon category is determined largely by individuals according to their own judgment. A style that appears merely "decorative" to one person might look "grotesque" to another. But, in order to simplify the process of description of styles, a system of tagging artists' work is used widely in the commercial art market. Whether they like it or not, the better known cartoonists each carry a tag attached to his style by the commercial art community.

The following descriptions of cartoon styles attempt to pinpoint some general characteristics of style tags.

Realistic. This is the least humorous of all cartoon styles, and is sometimes called "serious style." It contains a minimum of exaggeration in proportions as well as in human features and expressions. Used widely in adventure comics, textbooks, teen-age books, and comic books.

Semirealistic. Closely related to realistic style, except that its technique is somewhat looser and more sketchy.

Humorous. This is a general description applied to all styles of cartoons and humorous illustrations. But to most people it conveys the idea of one of the styles used by gag cartoonists.

Semihumorous. Approximate composite of "serious" and "humorous" styles. Description used mostly in advertising.

Decorative. All stylized cartoon styles are embraced by this category. Stylization implies some geometric simplification of drawings in their overall appearance and in detail.

Semidecorative. Not so highly stylized and less geometric than decorative style. This category covers a wide range of advertising and editorial illustrations.

Grotesque. Decorative cartoons with bizarre overtones fall in this category. Human figures, objects, and scenes must have some unnatural, fantastic appearance to qualify as grotesque. This style is used frequently in advertising promotion.

Whimsical. This is grotesque style with an additional grain of fancy and sophistication in handling of the ideas.

Designy. General description for all decorative styles in which much emphasis is put upon overall appearance of composition. "Designy" styles are often used to bring more punch into covers of booklets and other promotional material. Used also in posters and in packaging art.

Satirical. Applied mostly in political cartoons, where sarcasm and ridicule are the paramount aims of the drawing.

Selections of work by some of the best known cartoonists appear on the following pages. These selections attempt to show an approximate cross section of cartoon styles today.

Drawing by Blechman for "Travel and Resorts" supplement, The New York Times.

R. O. Blechman

Born in Brooklyn, Blechman graduated from Oberlin College. His career as a cartoonist began with the publication of the book "The Juggler of Our Lady" which he wrote and illustrated. The book became a selection of The Book-of-the-Month Club, and it was later filmed by CBS Terrytone. Blechman has done illustrations for Holiday, Fortune, Esquire, Time, Look, and McCall's magazines. He also designed, wrote and directed "The Christmas Birds" — a CBS-TV production, the winner of several prizes. Blechman is very active in drawing illustrations for advertising.

Although his drawings may appear spontaneous and carefree, they really result from the artist's careful selection of the best of many sketches he draws for each assignment. "I can do a drawing fifty or sixty times until it comes out right. Even the signature. I can do that fifty times too," says Blechman. Interesting comments about his work are expressed by Blechman in an interview for Graphic Designers in the U.S.A. ". . . I shudder at the word *artist*. I call myself a cartoonist. I would rather underplay than overplay myself — I am a cartoonist who occasionally does art work. I try to be an artist as often as possible. Like all artists, sometimes I succeed, and sometimes I fail. I didn't develop my style. It developed itself. It's something you can't control. It just happens if you have a point of view, if you feel strongly about things, somehow your style, your drawing, your life, all reflect it. So many people try to achieve a personal style and it just can't be done consciously."

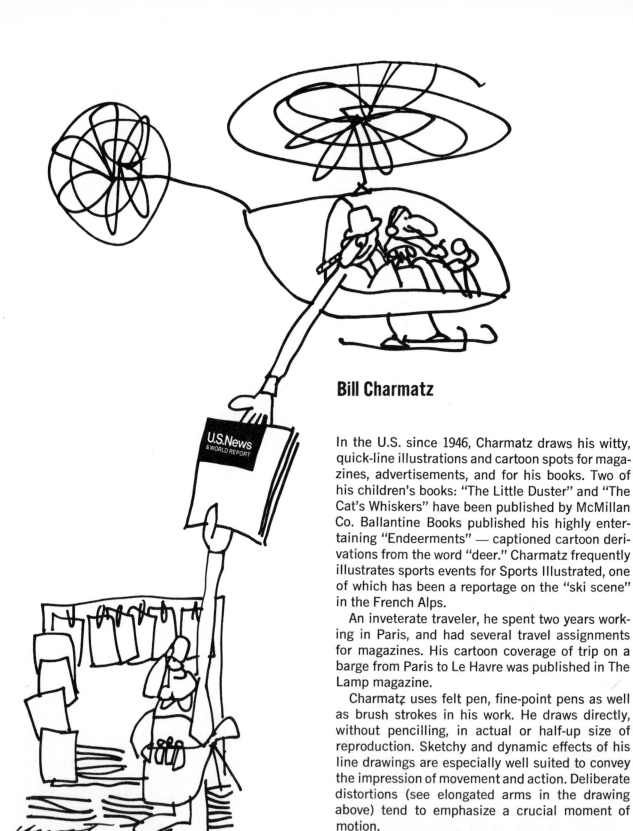

Bill Charmatz

In the U.S. since 1946, Charmatz draws his witty, quick-line illustrations and cartoon spots for magazines, advertisements, and for his books. Two of his children's books: "The Little Duster" and "The Cat's Whiskers" have been published by McMillan Co. Ballantine Books published his highly entertaining "Endeerments" — captioned cartoon derivations from the word "deer." Charmatz frequently illustrates sports events for Sports Illustrated, one of which has been a reportage on the "ski scene" in the French Alps.

An inveterate traveler, he spent two years working in Paris, and had several travel assignments for magazines. His cartoon coverage of trip on a barge from Paris to Le Havre was published in The Lamp magazine.

Charmatz uses felt pen, fine-point pens as well as brush strokes in his work. He draws directly, without pencilling, in actual or half-up size of reproduction. Sketchy and dynamic effects of his line drawings are especially well suited to convey the impression of movement and action. Deliberate distortions (see elongated arms in the drawing above) tend to emphasize a crucial moment of motion.

In his color illustrations, Charmatz uses acrylics and tempera colors on board.

Drawing by Charmatz for one of the series of posters for U.S. News & World Report magazine.

From "Still Another Number Book" by Seymour Chwast and Martin Moskof. 1971, McGraw-Hill Book Company. Used with permission.

Seymour Chwast

A good cartoonist is also a good designer. This view is clearly demonstrated in Chwast's interesting and original cartoon illustrations where structure of composition and amusing drawing combine to form a greatly appealing whole.

A native New Yorker, Chwast is active as a freelance designer-cartoonist in various fields of graphic art, and as a partner in Push Pin Studios in New York. Chwast's striking illustrations for "Sara's Granny and the Groodle", a children's book published by Doubleday, have won considerable acclaim. Success of his "designy" style used in children's books makes evident that young people are receptive to quite sophisticated graphics.

Chwast makes this comment about his work: "The concern in my work is with design rather than cartoon. This means that characterization, expression, and animation are less important to me than how my drawing relates to the two-dimensional shape to which it's being applied."

Drawing by Claude, Chicago Tribune trade ad: Foote, Cone & Belding Advertising Agency.

Claude

The style of Claude's cartoons, whether drawn for "The New Yorker" magazine gags, for story illustration, or for advertising, is strikingly vivacious. Its dynamic quality is due to spontaneity of swift pen line and to free distribution of grays throughout the composition. Claude's cartoons are outstanding for their atmosphere of effervescence, in which even inanimate objects seem to be in constant motion.

Says Claude about the style of his work:

"Style has never concerned me too much. It's always been enough of a problem getting the kind of drawing I want. Funny—with movement—and strong. And of course to look casual and effortless. Usually I do three to five drawings and up of a thing, and the best one out is the winner. Development and change is constant, I hope. Through effort and sweat one should improve his drawing —as a matter of course. Style can take care of itself."

Drawing by Einsel, Macy's International Food Festival newspaper ad. Art director: Ruby Friedland.

Walter Einsel

The highly decorative style of Einsel's work combines remarkable qualities, which make his drawings equally successful in advertising and editorial illustration.

By using a heavy contour line to hold the carefully executed details of figures and objects, Einsel succeeds in producing a striking over-all design effect. Because of the boldness and originality of his style, even small-space ads drawn by Einsel carry considerable impact.

In the full-page newspaper ad above, skillful grouping of panels within the cook's body preserves the unity of design while describing the numerous food items in graphic detail.

Cartoon by Jules Feiffer. © Copyright 1971 Jules Feiffer, Publishers-Hall Syndicate.

Jules Feiffer

What distinguishes Feiffer from cartoonists who can write is that he is really a writer who can also draw cartoons. In his unusual and highly sophisticated cartoon strip "Feiffer", he presents his witty and penetrating observations of people, their perplexing relationships, the tortuous problems they face in dealing with themselves and with their environment. Feiffer has a unique sense of caustic humor which he uses to express frankly his views on individual and social issues of the day. His cartoon books include: "Sick, Sick, Sick", "Passionella and Other Stories", "The Explainers", "Boy, Girl, Boy, Girl", "Feiffer's Album", and "Hold Me". Feiffer has written several books and plays.

His play "Little Murders" was produced on stage and as a successful film of the same name. "Munro", an animated cartoon based on a Feiffer story from "Passionella and Other Stories", won an Oscar as best short-subject cartoon.

Feiffer's comment on the style he used in the cartoon strip above, follows: "The object is to tell the story, so the style of the cartoon is controlled by the content. The drawing has to be direct and as simple as possible, even to the extent where necessary, of repeating the same face or figure from panel to panel, using slight changes of expression to emphasize points and to build to a climax."

Drawing by Folon. Courtesy of Horizon Magazine, Summer 1965.

Jean Michel Folon

Folon was born in Belgium where he studied architecture. Although his drawings and paintings show much preoccupation with urban structures, it is their psychological and sociological rather than architectural significance that engages his attention.

The labyrinthian mazes of his buildings, stairs or antennas seem to dwarf modern man who erected them. They symbolize the irony of man's efforts to find his way out of the perplexing conditions of his environment. But Folon does not laugh at people. They are pathetic rather than ridiculous, and Folon's art shows more compassion and tolerance than sarcasm. There is a poetic quality in his work in which he treats little people gently, with a sympathetic smile. Here is a cartoonist and artist with a tender heart, with no trace of venom or reproach. Folon says that he likes to look at people and their buildings. And when he looks at buildings — they look back at him.

In this country, his work has appeared in Fortune magazine, The New York Times, and in Horizon magazine. He is the winner of the Grand Prize in Italy's Third Biennial of Humor in Art.

Jacket illustration by Andre Francois for his book "You Are Ridiculous" published by Pantheon Books, Inc.

Andre Francois

The work of Francois should be qualified as fine art whether it is a painting, sculpture, stage set design or illustration. Imagination, humor, and powerful design reminiscent of Picasso's, are the hallmarks of his work. Most of his paintings and illustrations contain an element of surprise, in ideas or in graphics, reflecting Francois' unending search for the unusual and the new.

His work won him world-wide recognition. Acclaimed by many as one of the leading artists-humorists of our time, Francois has won many honors and awards on both European and American continents. Posters, cartoons, children's book illustrations and film commercials are part of his work in applied graphics. Many of his cartoons and covers were published by Punch and The New Yorker Magazine. In this country he is well known for his illustrations of books: "The Tattoed Sailor",

"Little Boy Brown", "Crocodile Tears", "Grodge Cat And The Window Cleaner", "The Story George Told Me" and "You Are Ridiculous" (which he wrote and illustrated).

Artist Ben Shahn stated in an article about Francois that he should be considered as one of the best artists-satirists of today along with Saul Steinberg, Ronald Searle and Robert Osborn. Cartoonist Walt Kelly wrote in an introduction to one of Francois' books: "The next best thing to being Francois himself and seeing his ideas flying free through the jungles of the mind is to see his drawings. But to be Francois and to see these ideas originally — there must be a privilege!".

Roumanian by birth, Francois became one of the most representative exponents of pungent French humor. He lives with his family in a village near Paris.

Caricature by Grossman of Congresswoman Shirley Chisholm for The New York Times.

Robert Grossman

In a surprising revival of air-brush technique, Grossman brings into the field of journalistic art an exciting new style in caricature. His continuous-tone, sculpturally modelled drawings capture and satirise the personality of the subjects while preserving unmistakable likeness. In his work, Grossman uses effectively two distinctive styles: highly controlled air-brush and sketchy pen-and-ink (see his self-portrait above).

Grossman's drawings have been published in many ads and as covers and editorial illustrations in New York Magazine, Time, The New York Times, and others.

Born in Manhattan, Grossman studied at Yale, where he was the editor of Yale Record. Before he

started free-lancing, he worked in cartoon editing department at The New Yorker. He lives with his wife, his three children and their pet iguana in Manhattan.

Commenting on his work, Grossman says: "While I have always enjoyed the simplicity of working in pen and ink, I had long wished for a way to give my — sometimes preposterous — conceptions the persuasive power of photography. To a degree I think I have achieved this with the airbrush. My technique is as follows: I first make a simple outline drawing on medium weight drawing paper. This I then cut apart and use as a set of stencils through which I spray watercolor onto a piece of smooth illustration board".

From a drawing in full color by Ginnie Hofmann. Courtesy of the artist and Cullen Rapp, Inc.

Ginnie Hofmann

Born in Toledo, Ohio, and married to an Episcopal clergyman, Ginnie Hofmann studied art at Cincinnati Art Academy, where she acquired knowledge of many techniques used in graphic art. She rounded out her art education with studies of art history. She finds her study period an invaluable asset in her present career as an illustrator.

Decorative charm of Hofmann's light-vein cartoon illustrations have delighted for many years the readers of such magazines as McCall's, Woman's Day, Parents, Mademoiselle, to mention a few. Her appealing drawings are also used frequently in advertising and sales promotion.

The style of her illustrations and ideas is indulgent and gentle-hearted — an admirable quality in the midst of the rough-and-tumble manner of the day. An accomplished craftsman, Hofmann uses color and subtle wash textures to obtain striking decorative effects.

She comments about her style: "I feel that humor is what has sustained my style over a long period of time. I like to vary techniques and explore new avenues of expression — but basic approach remains constant."

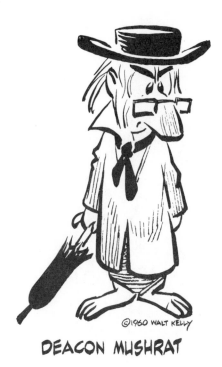

DEACON MUSHRAT

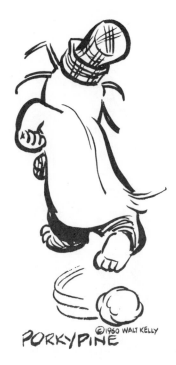

PORKYPINE

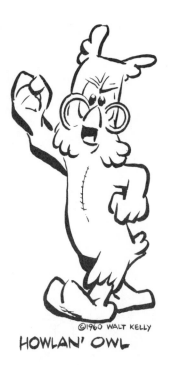

HOWLAN' OWL

Drawings by Walt Kelly. Courtesy of the artist.

Walt Kelly

There are critics of comic-strip art who maintain that this story-plus-pictures type of literature does not present the adult reader-viewer with enough challenge for imaginative interpretation and, therefore, does not contribute to his creative development.

Kelly's persuasive answer to these critics is contained in his delightful comic strip "Pogo," which engages the intelligence and stimulates the imagination of readers. Happenings in Pogo-fenokee-land and dialogues among its whimsical inhabitants sparkle with wit and satire.

Kelly's style of drawing is consistent with his style of writing and with his fine sense of humor. This consistency between "Pogo's" literary and artistic components enhances the strip's aesthetic value and gives it a place of honor among its many brethren.

A resounding success with the public since 1949, "Pogo" appears at present in more than 500 newspapers.

Kelly's own comment on his style follows:

"My style always surprises me. I am generally grateful if the drawing comes out clean and loose. However, I do not count on the result being anything to write about.

"My procedure varies also, though I usually lay everything out in blue pencil, to avoid pick-up of sketch lines in the engraving, and then spoil the whole effect by applying ink with a brush. This process can get very tight if I get too conscious of the line and attempt gaudy shadings in the weight. My object is to make the viewer believe that the animals I use are actually real. Their form should be believable, even though fantastic, and I dislike ugliness or cuteness. Whenever one of them turns cute, it is his own doing and I do not feel responsible.

"The best comment, naturally, is the drawings themselves."

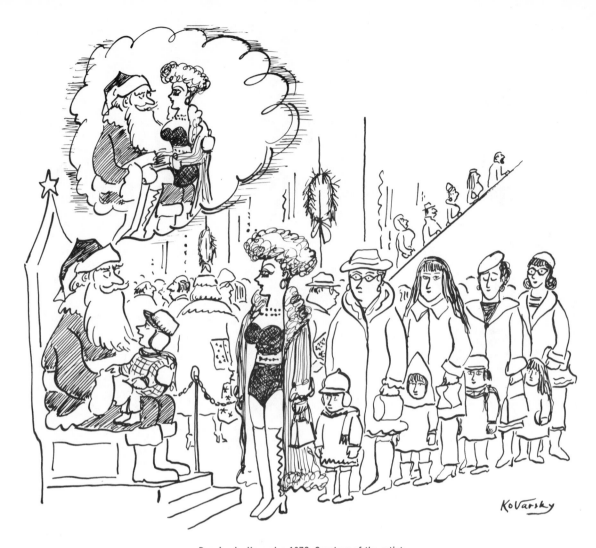

Drawing by Kovarsky, 1972. Courtesy of the artist.

Anatol Kovarsky

His captionless cartoons as well as his covers for "The New Yorker" magazine are unique in their style and humor. A product of several cultures, Kovarsky's humor transcends linguistic and folklore boundaries to achieve a trait of universality. His cartoons and illustrations have appeared in "Holiday" magazine, "The New York Times Sunday Magazine," and other publications. They are used frequently in advertising. "Kovarsky's World," a book published by Alfred A. Knopf, is a collection of cartoons that may serve as inspiration to cartoonists interested in captionless humor.

Kovarsky's interest in color and his need for uninhibited artistic expression find their outlet in his excellent oil paintings.

His comments on the drawing shown on this page follow: "General outline for this drawing was made in pencil on tracing paper, and the preliminary sketch was prepared in pen and ink. I used tracing box and crowquill pen to transfer the sketch on one-ply drawing paper for finished art. The use of this transfer technique allowed me to eliminate some 'roughness' as well as some superfluous details, thus clarifying my cartoon idea.

"I do not follow this procedure in all my cartoons. To achieve more spontaneity in line, I prefer working directly with pen rather than inking a penciled sketch."

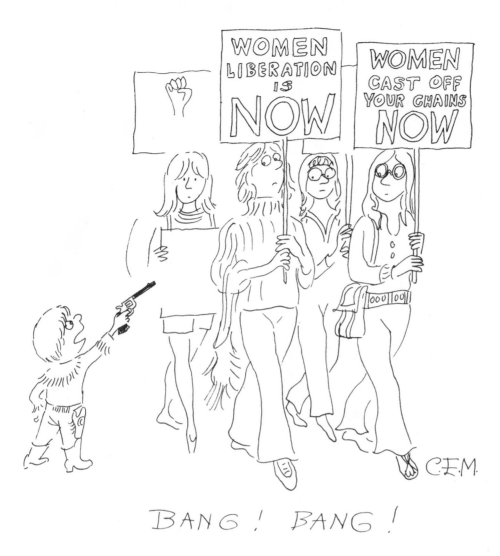

BANG ! BANG !

Drawing by C. E. M. Courtesy of the artist.

Charles E. Martin (C.E.M.)

A self-taught artist and cartoonist, Martin has been active in several fields in which he exercised successfully his considerable talent and imagination. He has been a scenic designer, art teacher, supervisor of art classes, newspaper artist, painter, and cartoonist. He had several exhibitions in New York art galleries and museums showing his posters, oils, watercolors and drawings. He is best known for his imaginative covers and cartoons for The New Yorker magazine, but his cartoons appear also in many other publications.

Martin's ideas denote keen intelligence, sagacity, and astute interest in the social issues of our times.

A thoroughly urban person, Martin was born in Boston, lives in New York City, but spends summers on Monhegan Island in Maine.

In connection with his work, Martin makes the following remarks: "I do not try to stay with a style. I feel that an artist should experiment constantly. I am old-fashioned about not separating the cartoonist from the fine artist. There are few really good contemporary American fine artists, and there are some fine craftsmen among American cartoonists. We are living in an evil and inartistic time, and the cartoonist as a social critic can be a powerful force for improvement in the human condition."

Beni Montresor

In a very personal and unique style, Montresor succeeds in creating an enchanted world of make-believe in his children's book illustrations. Looking at his illustrations one can almost feel like being in the audience watching a play on stage. Scintillating technique and colors used by Montresor give an illusion of theatrical spectacle in motion.

A native of Verona, Italy, Montresor has designed costumes and sets for Rossini's opera "Cinderella" in which he adapted his art to interpret the charm of this exquisite production for The Metropolitan Opera Company. His illustrations for "House of Flowers, House of Stars" and for "The Witches of Venice" display a very special talent for bringing theatrical effects into illustration of books. Montresor's fanciful, euphoric technique is very well suited for fables, legends and such allegorical tales as "May I Bring a Friend", which won the Caldecott award in 1965.

Montresor's art can bring delight to children and adults alike by being simple and direct on one hand, refined and cultivated on the other.

Bruno Munari

A versatile designer, Munari is at his best when creating books for children. Bold graphics, original textures and cut-outs combine here to effect impressive pictorial euphoria. Munari's special interest in achieving unusual decorative magic is apparent in his illustrated books, in his kinetic sculptures, and in his exploration of film as a medium of artistic expression. Bold design, hard-edge linear technique, and vigorous use of primary colors give Munari's illustrations an appearance of structural, quasi-architectural solidity and logic.

Munari lives in Milan, Italy. His work is frequently exhibited around the world. His books for children include such widely acclaimed titles as: "Bruno Munari's Zoo", "Bruno Munari's ABC", "The Elephant's Wish", "Who's There? Open The Door!", "Tic, Tac and Toc", and others.

By departing from the stereotypes of cartoon illustration, Munari assures for himself a unique place among children's book illustrators.

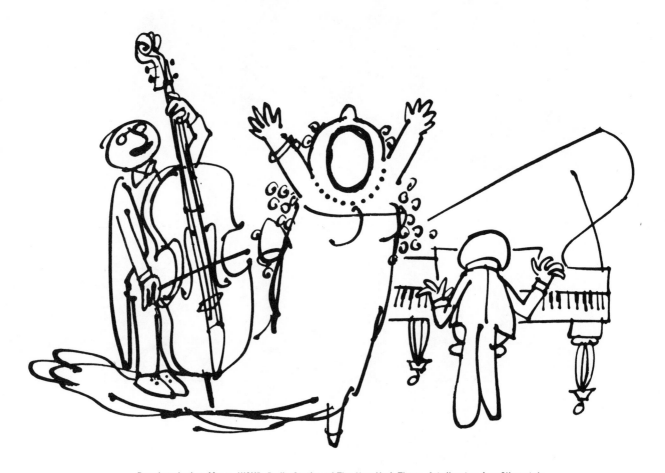

Drawings by Lou Myers, WQXR, Radio Station of The New York Times. Art director: Lou Silverstein.

Lou Myers

Myers' audacious style of drawing is symptomatic of an exuberant and uninhibited trend in American modern cartooning.

While many cartoon styles of the past depended largely on geometric stylization to achieve decorative effect, Myers' drawings produce decorative quality within a nongeometric concept of design. His gag cartoons, as well as his advertising drawings, communicate a great deal of sardonic gaiety. Myers developed his exhilarating style while living in Paris.

Here he tells about his experience:

"I lived in Paris with a French family, and for three years I had to pass through these charming throwbacks to get out to the gay boulevards. The questions they put to me! Having little French language, I could stand for an hour groping for a right word while they stood around inspecting me. Including Papa who looked like he'd been stomped on by Toulouse-Lautrec. That Papa would ask me a question, and as I gathered syntax he'd lean against the wall tired already. Out of incidents such as this came a thousand indexed images. So travel!

"I like to think that style should move always in new directions. That time saved by not embellishing a drawing gives me a chance to read about payola, and to worry about fallout. By dropping excess details in my cartoons, I can devote more time to search for better ideas."

We *pretend* to be VIGOROUS.....

Drawing by Osborn from his book "The Vulgarians," published by the New York Graphic Society, Greenwich, Conn. Art director: Burton Cumming.

Robert Osborn

The most significant aspect of Osborn's work is its satire. Osborn's drawings are used widely as editorial illustrations and in advertising, but his ideas and imagination find the most prolific outlet in book illustrations. These he draws for his own books and for books by other authors. His style reflects unmistakably several features of his personality: exuberance, integrity, and courage.

As a satirist, Osborn uses an uncompromising pencil to chastise the failings of our society and to attack vigorously some of the sacred cows of our era. By doing so, Osborn appeals to the intelligence of the public rather than to its vanity and credulity.

Boldness, spontaneity, and originality of style place his work in a unique position in American satirical cartooning.

In illustrating his book "The Vulgarians," Osborn impulsively varies his style from almost realistic to almost abstract. By doing this deliberately, he demonstrates more concern with direct interpretation of ideas than with consistency of style.

Reprinted from The Golden Treasury of Myths and Legends, illustrated by Alice and Martin Provensen. Copyright 1959 by Golden Press, Inc.

Alice and Martin Provensen

Through their work as artists, the Provensen team have contributed much toward raising the artistic standards of children's book illustration in this country. In fact, the Provensens have brought these standards close to the boundaries of fine art. The considerable success of their books has proved that there is no need to adjust the styles of children's book illustrations to the level of aesthetic immaturity and stereotype.

The Provensens' style has a great deal of sophistication in design and in humor. Good color and texture effects add interest and charm to their art.

The painting above is part of a double-spread illustration in full color for a legend entitled "The Oracle is Fulfilled." The mood of the story is reflected truthfully in this enchanting decorative illustration.

Drawing by Savignac, posters for Life Magazine.

Raymond Savignac

A popular French poster artist, Savignac became best known in this country for his series of twelve posters drawn for "Life" magazine. An exhibition of his work held at Young & Rubicam Advertising Agency attracted the attention of "Life" promotion executives and agency staff. Savignac's directness in interpreting copy ideas, his use of uncommon color combinations, and his sense of poster design contributed to the agency's choice of his style for "Life's" promotion campaign.

Savignac was imported from Paris to the New York offices of Young & Rubicam, where he painted his poster series under the watchful eye of art director Hugh White. In order to coordinate art with headline style, Savignac was requested to do headline lettering along with his art work, which he executed at one-tenth the actual size of the printed outdoor posters.

Drawing by Saxon. © 1967 The New Yorker Magazine, Inc.

Charles Saxon

One of the leading cartoonists of today, Saxon was born in New York City, graduated from Columbia University, and began his career as a magazine editor. He came to the fore as a highly successful cartoonist for The New Yorker magazine, as well as other national publications, books, and animation for television.

He uses whimsy and wit to satirize the mores of his generation with sophistication and great skill. Although Saxon is primarily known for his New Yorker covers, cartoons and spreads, he is frequently called on to illustrate campaigns for national advertisers.

Here are Saxon's comments on his work: "As a cartoonist, I seem to be identified to some extent with suburbia, but I hope my work reflects also my personal involvement in other social environments.

Almost all my ideas — even in advertisements — are my own. I don't like self-conscious gags — illustrations of wisecracks.

"I don't think about style — I try to solve each problem my own way, in whatever medium feels right: pencil, pen, pastel or brush. The structure of my drawings is predominantly linear. With a variety of graphic assignments, sometimes the solution is a simple figure, sometimes the complications of costume, architecture or decor require a complex staging."

When asked to comment on the strong influence his work has had on other artists, Saxon said, "I'd like to think the reason is its return to reportage of real people in real situations, in the tradition of such artists of the past as Daumier, Hogarth and Rowlandson."

Drawings by Schulz. Courtesy © 1971 United Feature Syndicate, Inc.

Charles M. Schulz

The popularity of a comic strip depends on how closely the strip's contents and art relate to interests, intellect and taste of the readers. Schulz has succeeded in appealing to all three in his highly engaging strip "Peanuts." Schulz loves children and he has five real-life "peanuts" of his own. "Occasionally I do use an actual incident or an apt remark as the basis for a strip," says Schulz, "but mostly I think the characters in the strip have their own individual personalities that are just as real to me as those of my own children."

Good ol' Charlie Brown, Lucy, Linus, Violet, Schroeder, as well as the inimitable Snoopy, have all become daily companions of millions of Americans since 1950, the year "Peanuts" began its phenomenal course.

Schulz began his career as a cartoonist in Minneapolis, but moved later to Sebastopol, California, where he lives now with his family. "Peanuts" is distributed throughout the world. It has won for its creator many honors and awards. National Cartoonists' Society voted Schulz "Cartoonist of the Year" in 1956 and again in 1964. Two American colleges awarded Schulz honorary doctorate degrees in humane letters. His TV Special "A Charlie Brown Christmas" has earned a Peabody Award and a Television Academy Emmy Award. Several other TV Specials by Schulz have been broadcast several times each. A musical, "You're A Good Man, Charlie Brown" has played to capacity audiences for several years.

Schulz's own version of his ascension to fame is simple and unassuming: "All my life, I wanted to draw a comic strip — and now I'm doing it, and people seem to like it. I can't imagine anything I'd rather do more than what I'm doing."

Drawing by Ronald Searle, © Copyright 1966 Ronald Searle. From "The Square Egg and the Vicious Circle" published by Stephen Green Press, Vermont.

Ronald Searle

Born in Cambridge, England, Searle began his career as a cartoonist soon after the Second World War. A powerful intermixture of biting satire and inimitable craftsmanship has won for his work universal acclaim by the public and admiration of his peers. Said artist Ben Shahn of Searle's work: "Searle brings into his work most distinguished intelligence, one with something to say, full of observations, meanings and infinite toleration and sympathy for the human condition." Dazzling graphic effect of Searle's drawings is achieved by free and spontaneous use of brush, pen, and wash in masterfully integrated combinations. The artist's concern for minute details brings into his cartoons the heartbeat of reality despite the overall atmosphere of fantasmagoria hovering over all of his art. By using his vibrant technique, Searle can create an illusion of dynamic motion — an intrinsic and highly praised quality in action cartooning.

Searle has illustrated more than forty books, designed sets and costumes for films, traveled widely on feature story assignments in Europe and in America, has done extensive work for leading magazines. The drawing above is one of some 100 illustrations from his book "The Square Egg and the Vicious Circle" — a collection of penetrating and hilarious observations by a master satirist.

Winner of many awards, Searle was voted in 1960 "Cartoonist of the Year" by National Cartoonist Society of America. His paintings and drawings have been shown in one-man exhibitions in London and New York. In this country, his work has appeared in The New Yorker, Life, The New York Times, and in other publications.

Art Seiden's illustration from "My Great Events Calendar 1970". Used by permission of American Heritage Press, a Division of McGraw-Hill, Inc.

Art Seiden

A skillful craftsman and a fine colorist, Seiden is primarily known for his illustrations of children's books. His "humanized" animals have considerable charm and great appeal to the young. His figures have contours of delicate pen line, and are painted with overlapping color washes. Composition is clever and harmoniously balanced. Backgrounds are painted with subdued, light wash.

Seiden's animals are debonair and friendly. "I have been told that my face usually appears in my illustrations. I guess every artist draws himself unconsciously," says Seiden. "After basic training as a designer, I went into the direction of book

illustration where design is a vital necessity. After doing numerous books with a flat, decorative look, I decided that I needed a different approach. I went to The Art Students League to study watercolor painting, and started applying it in my work".

Several of the children's books illustrated by Seiden became selections of The American Institute of Graphic Arts' "Fifty Best Books of the Year". Seiden illustrates children's books for such publishers as Reader's Digest, Grosset & Dunlap, The Golden Press, and others.

A New Yorker, he lives on Long Island with his wife and daughter, both artists.

Saul Steinberg

Born in Roumania, Steinberg spent his twenties in Milan, Italy, where he finished his studies of architecture, and where he began working as a cartoonist for newspapers and magazines. He emerged in America during the turbulent times of German Nazism, Italian Fascism, preposterous emigration red-tape, and the macabre events of the Second World War. Steinberg's satirical outlook on people with their nonsensical views of themselves, their sick egos, their absurd rules and behavior, stemmed undoubtedly from his personal experiences. Artist, social commentator, philosopher and finally a cartoonist, Steinberg's art reaches beyond satire and humor. His work expresses philosophy and intellect of an artist who offers judgment and also asks many questions in a pictorial, non-verbal language. There are statements in Steinberg's art, but there are also many queries and unfinished conclusions. In the pandemonium of his ideas, people emerge as comic actors wearing masks of their illusions about themselves. Steinberg uses his linear language with artistry and precision to deride, berate and expose the most unartistic and imprecise behavior of man. His darts are made of calligraphy, numbers, architecture, landscapes, furniture, animals, abstract graffiti, caricatures of men and women.

Steinberg's cartoon books include: "All In Line", "The Passport", "The Labyrinth", and "The New World". His covers and cartoons appear frequently in The New Yorker. The French Government honored him with the title of Chevalier des Arts et Lettres. He is the first artist-in-residence at the Smithsonian Institution in Washington.

Drawing by David Stone Martin, Verve Records. Art director: Merle Shore.

David Stone Martin

It is debatable whether Martin's work should be called cartoon, design, or illustration. His style shows a successful integration of the best features contained in all three of these classifications. Martin's work is used widely in record sleeves, book jackets, editorial illustration, and advertising. Martin works mostly on hard-surface water-color paper, using sensitive pen-and-ink line technique as a skeletal basis for transparent color washes. His unusual skill in building a bold design with delicate and elegant pen line has earned for him a nation-wide reputation.

Notice the exquisite rhythm in composition of the drawing above, in which uninterrupted continuity of design presents an effect of abstraction, while preserving the perfect readability of a realistic illustration. Heavier lines in this drawing accentuate the motions of the drum player and simultaneously contribute to the structure of a powerful design.

Tomi Ungerer

Ungerer's style derives from his brand of humor rather than from a peculiar technique. As an artist, he looks at human foibles with a grain of irony and with intelligent awareness of "imperfect man's behavior in an imperfect society." Born in France, Ungerer wandered through Europe and North Africa before reaching New York.

His design concept and his frequent use of collages indicate a strong influence of modern art on his work.

Ungerer says that he has an omnipresent urge to change the style of his work in order to avoid wearisome uniformity. He does not believe in following a style formula all the time. Although his clients urge him to maintain his once-established style patterns, Ungerer tries to bring into his work changes and innovations whenever possible. But he preserves his individuality.

HOW TO DEVELOP AN INDIVIDUAL STYLE

The distinctive, characteristic manner in which a work of art is executed is called its style.

In humorous graphic art, the most important components of style are design, humor, and technique. Cartoon style is considered original when its design concept, its humor, and its technique are unique and personal. When the combination of these three components yield drawings similar to large numbers of drawings by a large number of other artists, the style is considered "impersonal" or "indefinite." Such a style rarely, if ever, achieves considerable recognition.

Artists who are animated by the desire to become well known for their work and who have adequate abilities should try to develop their own individually recognizable style.

Talent for drawing is in general of unexplainable origin—possibly it is inborn. But it seems highly improbable that a particular style—which always reflects cultural trends of its time—can appear without having absorbed some definite influences from the outside. The style of an artist as a child is different from his style as an adult; therefore, it may be assumed that transient influences to which young artists are subjected affect and determine their future styles.

Social environment, family, teachers, and friends play an important role in shaping young persons' tastes in art. Physical surroundings, including the home and the natural environment, contribute to the establishment of the aesthetic roots from which the taste for color and design grows. Finally, general educational standards as well as illustrated children's books and textbooks have important effects upon a child's aesthetic growth.

It can also be assumed that the same environmental, educational, and intellectual experiences that develop an aesthetic sense are causative factors in the formation and development of a sense of humor. And so it seems that technique is the only remaining factor needed for the development of a style in the early stages of the study of cartooning.

There are two avenues open to the artist in the task of learning a technique that will reflect adequately his own sense of design and of humor. First, he may try to "invent" an original technique of his own. For this purpose, he should experiment extensively by using different drawing media and materials, both conventional and of his own device. The drawings that follow show some of the many graphic ways in which it is possible to finish the same sketch. If this method of search for a technique does not appeal to the artist or if it does not prove successful, another method can be tried, that of "borrowing" another artist's technique. The use of the same media and the imitation of graphic effects are actually the only elements that one artist may successfully "borrow" from another. For it is hardly possible to imitate another artist's personality, sense of humor, and design; these things are acquired in the course of living and developing.

Most cartoonists have been influenced willingly or unwillingly by other cartoonists in their original choice of drawing media and technique. This circumstance alone does not stamp them as imitators any more than those fine-art painters are imitators who use oil paints and brushes in a manner inspired by the great masters. Some professional cartoonists use more than one style in their work and are competent craftsmen in more than one technique. These versatile, all-round cartoonists have an excellent chance to pursue their careers successfully, either as free-lancers or as salaried artists. Their diversified skills are highly appreciated by such cartoon users as advertising art studios, publishers, company art departments, creative printers, and many others.

A cartoonist's style rarely remains static. In most cases, the style undergoes automatic and progressive changes that are conditioned by the general evolution of trends in art, by the artist's increased experience, and, finally, by changes in his personality.

Some cartoonists rise to fame because of their sense of humor and their talent for writing rather than because of their drawing techniques. There are several noted cartoonists whose work is recognized for its wit and literary attractiveness and not for its graphic qualities.

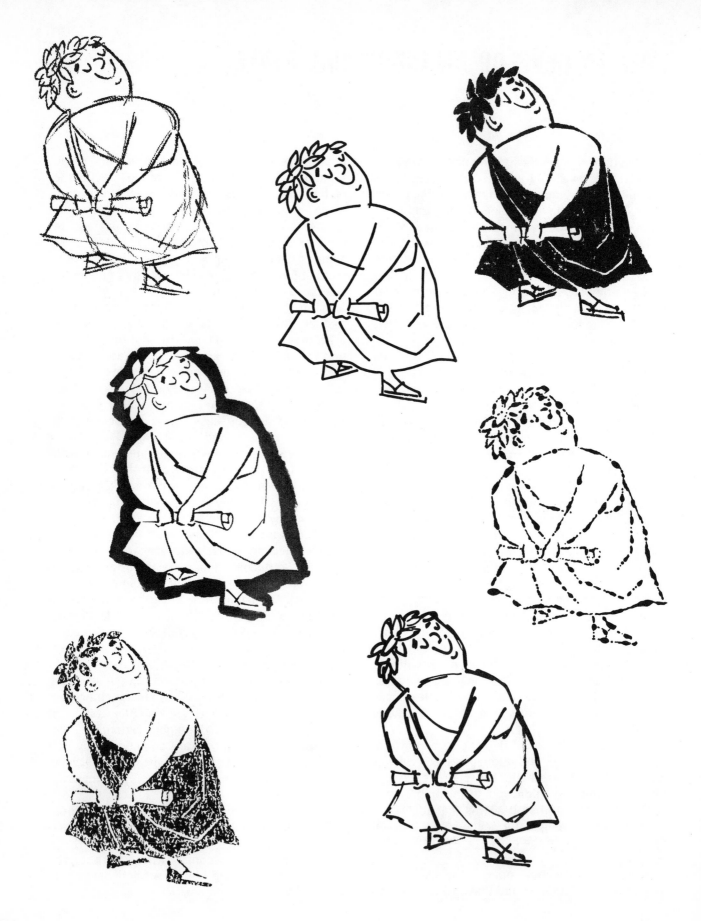

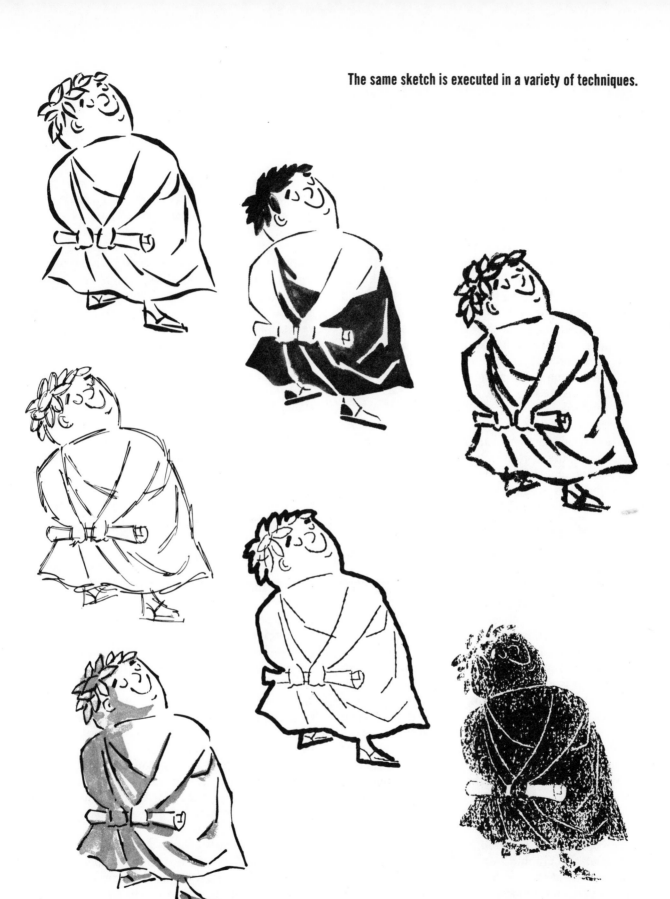

The same sketch is executed in a variety of techniques.

GRAPHIC HUMOR AND IDEAS

The types of humor conveyed by cartoonists in their work vary as much as styles and techniques. Graphic humor can be mild or sharp, naive or clever, logical or absurd, stereotyped or original, hostile or sympathetic. But, whatever its type, humor must express some comical side of life or fantasy. In order to be humorous, cartoons should exhibit at least one of the following traits:

Exaggeration in proportions of figures
Exaggeration in facial expressions
Exaggeration in action and gestures
Contrast (small vs. large, strong vs. weak, etc.)
The unexpected
The absurd
The comic

However, reaction to humor does not depend merely on the cartoonist's wit or skill. Different observers react differently to the same joke or drawing, and what seems obvious and comical to one person may appear obscure and dull to another. Graphic humor designed for a specific readership must be so conceived that it is easily understood and must also, somehow, violate normality and this readership's accepted clichés of behavior. It must shock without offending. The intellectual level of the readers—their ages, habits, beliefs, and conventions—must be considered by the cartoonist in his search for humorous cartoon ideas. The outer appearance of humorous characters should also be given some special attention. It is well known that every person identifies himself easily with sympathetic cartoon characters but is reluctant to accept his resemblance to the unattractive villains. In advertising especially, whenever an idea is intended to appeal to women readers, feminine cartoon characters should be given sympathetic consideration in order to produce the desired effect of identification (male readers are considered somewhat less sensitive in this respect).

In order to be acceptable in most fields of commercial art, graphic humor must elude or soft-pedal several themes that are subject to popular inhibitions and taboos. In different countries, different degrees of restrictive conditions are applied to cartoon humor. In the United States, the following subjects must be manipulated by cartoonists with forethought and tact:

POLITICS. Except in political cartoons, the partisan activities of the two principal political parties, Democratic and Republican, should not be ridiculed too harshly, to avoid displeasing readers who are the followers of either party. Gags or advertisements appearing in magazines and newspapers are designed to appeal to most possible buyers of products and services advertised in these publications. It is therefore necessary to remain as nonpartisan as possible.

NATIONAL HISTORY. Pathetic historical events, national holidays, and past or present heroes should not be derided in cartoon humor.

RELIGION. Although mild and sympathetic humor related to clergymen, monks, nuns, and church activities is acceptable, sarcasm and satire about religious matters are unthinkable in cartoon humor. Nevertheless, the religious rites and customs of primitive peoples are frequently made fun of in cartoon gags.

EROTICISM. Uninhibited humor in this department is taboo. Completely nude male figures are excluded from cartoon illustration. Nude female figures can be used, provided that some anatomical simplifications are tactfully observed. Scenes of love and romance have to conform to the accepted standards of propriety. Situations defying proper formality are likely to be stigmatized as unacceptable for public consumption and branded as pornography. Hollywood's self-imposed standards of morality seem to be the criteria followed by commercial artists in this area.

RACE. Because of widespread sensitivity toward racial problems, humor exploiting racial differences is not tolerated in cartoons. Such details as shape of nose or color of skin are looked upon by clients with understandable concern.

PHYSICAL DISABILITIES AND DISEASES. Deformities and disabilities are not acceptable as subjects for cartoon humor. Humorous or sarcastic approaches to such diseases as cancer, heart ailments, tuberculosis, etc., are taboo. Only minor

afflictions, such as the common cold, near-sightedness, cough, or headache may be laughed at by cartoonists. Some exceptions in restrictions toward serious illnesses are allowed. For example: people suffering from ulcers are an acceptable object for humor, and the confusion resulting from mental illness is a frequent topic of gags.

The regimentation of humorous ideas by cartoonists is an automatic and instinctive process, as far as professionals are concerned. But beginners may have to adjust their humorous thinking by following the restrictions mentioned above.

In order to stimulate memory and imagination in the search for humorous ideas, the beginning cartoonist may prepare two charts dealing with subjects for humorous ideas: general themes and special events.

GENERAL THEMES

Listed below are some themes dealing with everyday events and activities. These are virtually boundless, and so every artist should limit his selection to the themes most familiar to him, and draft his chart accordingly.
Domestic life. Travel. Suburban living. Office events. Sports. Hospitals and doctors. Dentist's office. Children. Car driving. Police and thieves. Courtroom scenes. Family birthdays. Farm life. Animal life. Vacations. Country life. Small-town events. City life. Foreign countries. Space travel. Military life. Fine arts. Work and workmen. Games. Teacher and pupils. Theater, radio, and TV. Stores, salesmen, and sales. Desert islands and survivors. Psychiatrist's office. Natives of foreign countries. American Indians. Parties. Bars and restaurants. Tramps and beggars. Pretty girls. Parties.

SPECIAL EVENTS

This partial list contains special seasonal events arranged in monthly order. It may be used separately or in conjunction with the preceding chart. Seasonal sports events, conventions, grand openings, store sales, etc., should be added to monthly events in chronological order.
January: New Year, First National Election, Benjamin Franklin's birthday, F. D. Roosevelt's birthday. February: Groundhog Day, Lincoln's birthday, Saint Valentine's Day, Washington's birthday. March: Ash Wednesday, Saint Patrick's Day, First day of spring. April: April Fools' Day, Palm Sunday, Passover, Jefferson's birthday, Good Friday, Easter Sunday. May: Mother's Day, Memorial Day, Lindbergh's flight, 1927. June: Flag Day, Bunker Hill Day, Father's Day, First day of summer. July: Independence Day, John Q. Adams's birthday, Hawaii annexed, 1898, Beginning of First World War, 1914. August: Panama Canal opening, 1914, Japan's surrender, 1945. September: V-J Day, Labor Day, Back to school, Constitution adopted, 1787, Rosh Hashana, First day of autumn. October: Columbus Day, Yom Kippur, Eisenhower's birthday, Theodore Roosevelt's birthday, Halloween. November: All Saints' Day, Veterans' Day, Thanksgiving, Byrd at South Pole, 1929. December: Pearl Harbor, 1941, Wright's first flight, 1903, Christmas, Woodrow Wilson's birthday, First day of winter, Pilgrim's landing, 1620.

There are no general formulas for finding humorous ideas. Every cartoonist will develop his own creative method in due time. However, in the early stages of his creative growth, the artist may try, pencil in hand, to organize his idea-finding process in the following way. After choosing an appropriate theme from the chart, he will proceed to select three topics related to the theme. These three topics should have conjointly some humorous potentialities. For example: if the chosen theme is "domestic life," the three selected topics could be "husband," "mother-in-law," and "refrigerator," and these should be sketched together in various situations and then shuffled and rearranged till humorous ideas emerge. A multitude of comic situations may derive from these manipulations. However, should there be difficulty in finding an acceptable humorous idea, one of the three topics should be replaced, in the hope of greater inspiration. For instance, the refrigerator could be replaced by a car, a vacuum cleaner, a TV set, or a dog. At different moments one object may prove more inspiring to the artist than another.

Some examples of triads of combined items having humorous potentialities are listed below for exercise purposes:
Driver, wrecked car, tree. Hunter, lion, cactus. Mother, boy, paint. Boss, secretary, wife. Dentist, patient, baseball bat. Psychoanalyst, patient, rabbit. Museum, visitor, statue. Plumber, housewife, bathtub. Eskimo, penguin, igloo. Skier, slope, tree. Farmer, cow, flying saucer. Cocktail party, guests, skeleton. Indian, totem pole, electric drill. Picnic, family, skunk. Sheik, harem, salesman.

THE CARTOONIST'S MARKETS

Humorous illustrations and cartoons are used in virtually all fields of advertising and publishing. These fields are the cartoonist's potential markets.

What qualifies an artist to fit into one or more of these markets? In most instances, a combination of his experience—the opportunities for work that have been offered him—and his adaptability to the diversity of market requirements.

The markets listed and briefly described below represent most of the typical fields in which cartoonists may seek employment or free-lancing opportunities.

SPACE ADVERTISING. Ads appearing in national and trade magazines and in newspapers. All national and most trade ads are handled by advertising agencies, which call on free-lance artists directly or through studios and agents. Art directors and agency art buyers are in charge of choosing artists to do finished art. In smaller agencies, salaried artists and art directors are sometimes commissioned to prepare finished illustrations, for which they are paid separately. Some large agencies employ sketchmen for cartoon renderings in comprehensives.

OUTDOOR ADVERTISING. Posters, car cards, window streamers. Large posters originate in advertising agencies and litho houses, which call on free-lance artists for finished art. Short "runs" of smaller posters (mostly printed by the silk-screen process or by offset) are handled by "creative printers," who use staff artists or freelancers.

POINT-OF-SALE (OR POINT-OF-PURCHASE). Window and counter displays, display cards, exhibits, etc. Staff or free-lance artists are called upon by companies or window-display shops to prepare sketches, renderings, and, sometimes, finished art.

DIRECT MAIL. All promotional material for mailing: booklets, pamphlets, brochures, folders, etc. These are prepared mostly by sales-promotion departments of companies, by smaller agencies, by studios, and by company public-relations departments. Free-lance as well as salaried artists are called on to prepare finished art.

SPOT CARTOONS. Small cartoon illustrations are called spots. They are used for many purposes in a variety of fields of advertising and publishing.

GREETING CARDS. Most greeting-card publishers have their own printing plants. Some publishers hire staff artists; others buy designs for cards from free-lancers who submit ideas in the form of comprehensives. Serious publishers pay for comprehensives as well as for finished art.

MAGAZINE COVERS. Some publishers of trade or special magazines use humorous or design covers for their publications. Staff artists or free-lancers prepare the art. National magazines such as "The New Yorker" buy largely from free-lance artists who are their regular contributors.

BOOK JACKETS. Book publishers use their staff or free-lance artists to design book jackets.

RECORD SLEEVES. Record publishers buy art for sleeves from artists who have a good sense of design and color. Artists are required to furnish ideas, comprehensives, and finished art.

BOOK ILLUSTRATION. This broad field covers juvenile, teen-age, and adult fiction, humor, and textbooks. Art editors, or art directors buy all styles of cartoons and illustrations from free-lancers.

MAGAZINE CARTOONING. Gag cartoons are presented to cartoon editors of major magazines in the form of rough sketches (every Wednesday in person, or by third-class mail). Roughs are drawn in pencil on typewriter paper. Gag cartoonists use either their own ideas for their gags or those of a gagman, who receives 25 per cent of the price paid to the cartoonist for the accepted gag. The

accepted roughs are given back to the artist to be finished. Beginners should present, along with their roughs, a few finished cartoons to show the style of their work.

EDITORIAL ILLUSTRATION. Cartoons concerned with political, social, or economic problems of the day fall into this category. Editorial markets include newspapers and magazines devoted to public affairs. The work of many editorial cartoonists is syndicated for distribution to newspapers throughout the country.

STORY ILLUSTRATION. Art editors of magazines and newspaper Sunday supplements call on freelance artists to illustrate various features. Major illustrations as well as spot drawings are used.

SPECIAL FEATURES. Free-lance artists may submit ingenious and timely humorously illustrated themes to magazines and newspapers. If the theme suits the format of the publication and if it harmonizes with editorial policy, there is always a chance of having the feature accepted for publication.

SYNDICATED CARTOONS. Most comic and adventure strips, gag strips, comic pages, gag panels, and sports cartoons are syndicated. Syndicates will consider submitted ideas, which must represent at least a two-week supply of material —black-and-white for daily editions plus two color pages for Sunday editions. One matte (dull-surface) photostat of black-and-white art should be painted with transparent water colors to show the final effect of the work. Submitted art work should be finished, ready for reproduction, with balloons and lettering. A typewritten outline describing the story of the features must be attached.

COMIC MAGAZINES. There are approximately 250 of these magazines, which are published in four colors monthly, bimonthly, or quarterly. They are the product of collective work by writers, editors, and artists. Free-lance as well as salaried artists specialize in penciling, inking, and lettering for comic-magazine publishers.

CHARTS AND SALES PRESENTATIONS. Cartoonists can adapt their skill easily to this field, which includes charts, maps, graphs, story boards, easel

presentations, dioramas, slide presentations, diagrams, and reports. Advertising agencies, studios, and company art departments use free-lance or staff artists for this work, which is done for presentation, not for reproduction.

TELEVISION COMMERCIALS. Advertising-agency TV departments and TV-animation studios offer jobs and some free-lance opportunities to cartoonists. TV story boards are prepared through the cooperation of script writers and artists, whose **audio** (announcer words, sounds) and **video** (pictures) contributions are blended to achieve a TV commercial. Animation studios employ staffs of artist-animators to prepare film strips for projection on TV.

ANIMATED CARTOONS. Animated movie cartoons employ large staffs of artists with diversified duties. Animators, animators' assistants, colorists, inkers, and background artists work together with directors, producers, editors, sound men, and musicians. Quite a number of successful cartoonists today began their careers in animated-cartoon studios, from which they graduated into magazine cartooning and other fields.

In smaller towns throughout the country, local newspapers, retail stores, supermarkets, manufacturers and printers offer excellent opportunities to cartoonists. Local newspaper editors are always interested in small-space promotional ideas to attract local advertisers. They are always in the market for good editorial cartoons, for regional comic strips, for sports cartoons, and for small editorial spots.

For many a cartoonist, his home town is a receptive starting place, for part-time work at first, for a permanent occupation later.

Prices for art work vary in different localities. Cartoonists should acquire information about local prices from home-town professionals before they begin to approach prospective customers. Also, they should prepare a portfolio containing other work than that which they intend to sell to the client.

Reproductions of my own work on the following pages have been selected as examples of one free-lance cartoonist's adaptation to different markets. Brief comments accompanying the reproductions contain miscellaneous information that may prove of interest to cartoonists.

1

2

1. Front and back covers, and one of the inside illustrations for public relations booklet published by Employee Relations, Inc. Printed in two colors. Client suggested that cover be handled in a "designy" style to intrigue and attract attention. But light-vein contents were illustrated with cartoons.

2. Illustrations for a double-spread in a large promotion brochure for Sperry & Hutchinson, Incentive Division. Illustrations were prepared for full-color reproduction.

3. Travel folder for Sylvania. This full-color, die-cut promotion piece was folded to fit 12 x 4¾" mailing size. Unfolded, it was designed to stand upright as a miniature Chinese screen.

Ticket holder for S & H Travel Awards, Inc. Reproduced in four colors.

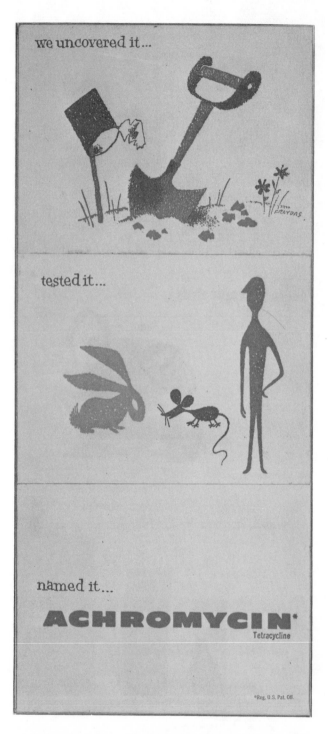

we uncovered it...

tested it...

named it...

ACHROMYCIN*
Tetracycline

*Reg. U.S. Pat. Off.

Cover and one of inside pages for Lederle Laboratories booklet advertising Achromycin.

Book jacket design for Sterling Publishing Co., Inc.
Printed in three colors.

Book jacket design for Doubleday & Company, Inc.

CORPORATE REPORTS

Illustration for American Business Press, Inc. published as a supplement to the Sunday Times.

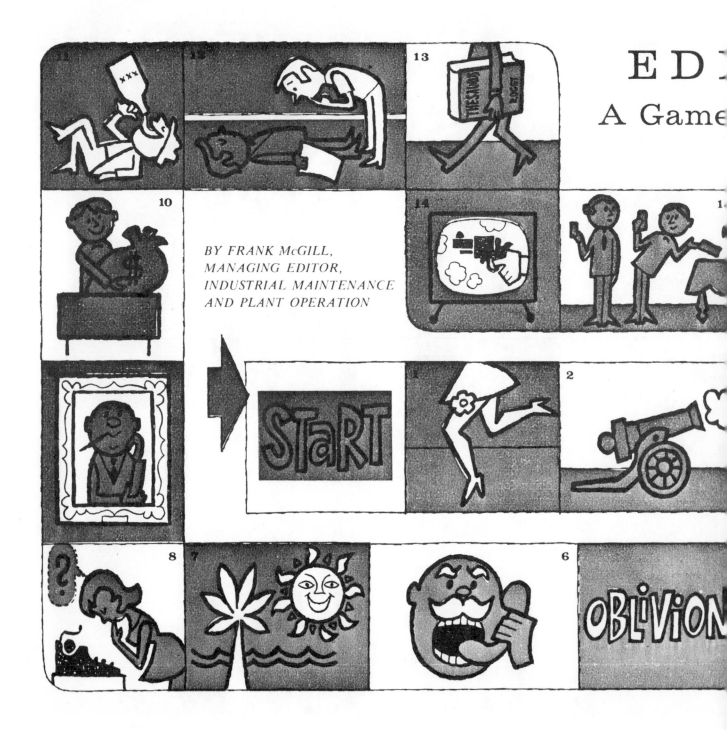

Double-spread illustration in two colors for Better Editing magazine. Working in close cooperation with editor Cortland Gray Smith, an artist himself, produces excellent results.

public relations issue

VOLUME 37 NUMBER 7 MARCH

Wilson Library Bulletin

Cover design in two colors. Writer's dream of success is the theme for this public relations issue of the magazine.

Full-color cover design for Today's Crosswords magazine. The topic of travel is in tune with the time of magazine's appearance on newsstands — summer vacation time.

Details in this cover design relate to the contents of the magazine dealing with activities on Long Island.

GREETING CARDS

Christmas cards for American Artists Group, Inc. The greeting card market is open to free-lance artists with all kinds of styles and techniques. Artists should submit ideas in finished or nearly finished form.

20 x 30″ travel poster for Sylvania Electric Products, Inc. Drawn in actual size in black pen lines. The printer followed the lines as guidelines for colors which were indicated on a single overlay.

PACKAGE DESIGN

Two of the series of wraps for Barton's round tins containing candy. Full-color offset printing. Bright colors of illustrations are planned for special appeal to youngsters.

CHILDREN'S BOOK ILLUSTRATION

It was a huge statue of a man riding a horse. The policeman standing at the foot of the statue suddenly saw Hoppy sitting up there, and blew his whistle.

Full-color double-spread illustration from the book, "Hoppy the Curious Kangaroo" which I wrote and illustrated. Published by Grosset & Dunlap, Inc.

All 14 things concealed here start with F. Can you name them?

Each monster hides a different letter of the alphabet. Can you find all 26?

56

57

A page and a double-spread in full-color from GREAT FIND-ITS
© 1977 by Western Publishing Company, Inc.

A double-spread in full-color from MAZES, MAZES
© 1977 by Western Publishing Company, Inc.

Cover and an inside page in full color from
NATURE CROSSWORD PUZZLES © 1976 by Western Publishing Company, Inc.

Two of a series of stills for Dan Rivers Cottons TV promotion. Complete series showed in a humorous vein the evolution of feminine fashions.

LETTERING

Throughout history, the contribution of letters of the alphabet to the development of man has been remarkable. The primitive man carving notches on his hunting weapon to remember how many animals fell to his manly skill, was the real precursor of today's lettering artist. Cave paintings were probably the first pictorial representations depicting man's life. Picture-writing or "pictographs" began as rock-tracing.

Sambians, Semites, Chinese, Egyptians, Aztecs and Mayas were the first to develop the word-writing art in which single symbols or designs pictured the words. Closer to home, the American Indians enjoyed telling stories in pictures long before the first Pilgrim set foot on their soil.

In time, every object, function, and even abstract concepts found their symbols in picture-writing. Along with picture-words, we assume, there was also present the language of sounds, a phonetic language — the spoken word.

As life became more complex, and there were more and more things to remember and to talk about, the need for more specific definition of words became very important. It all began in the eastern Mediterranean, where Phoenicians, Semites, Cretans, Babylonians and Egyptians had to cope with such problems as trade, transportation, religions and wars. Someone came up with the idea that if the sounds man was making in saying words could be shown in script, it would be much easier to tell about things at a distance. The resourceful Greeks started it and the Romans followed it up. Greek letters of the alphabet were born as an orderly system of characters or signs. Each letter was different, each represented a different sound, and each was related somewhat to the first sound in the spoken word. For example: if the Greek "inventor" of written letters had been an English speaking person, he would make M as in Man, W as in Woman, H as in House, etc. Our word Alphabet derives from the first two Greek letters: Alpha and Beta.

Early Greek writing was done in capital letters (also called Uncials or Majuscules) around 400 B.C. The use of small letters (minuscules) was added to word-writing much later, around 700 A.D.

The Romans redesigned the Greek alphabet making it more graceful and refined to suit better their taste and the style of their architecture. More delicate and dignified, Roman letters were also destined to express the glory of the Roman empire.

Development of styles generally follows the trends in cultures and in the arts. Diversity of styles in modern lettering and type reflects the multitude of artistic expressions in our days. It also responds to various needs, aesthetic or practical, in such fields as publishing, architecture, and advertising.

In all areas of applied arts, including cartooning, some knowledge of lettering can be of great help. An ability to combine drawing with hand lettering or with type may inspire creative designs for promotional material, displays, packaging, book jackets, logos, trademarks, posters and greeting cards. Lettering can be used in different forms.

1. TYPOGRAPHY

Typography is a technique which allows individual letters (characters or types) to be set mechanically or by hand to form lines of words. These types are made of metal. There are over 500 different styles of type faces. Each style is available in several sizes measured in "points".

AEFGHIJKLMNOPQRSTUVWXYZABC aefghijklmnopqrstuvwxyzabcd $456
6 POINT

ADEFGH I JKLMNOPQSTUVW aefghijklmnopqrstuvwxy $789
8 POINT

AXYZABCDEFGHIJKLM ayzabcdefghijklmnopq $012
10 POINT

ANOPQRSTUVWXY arstuvwxyzabcdefg $345
12 POINT

AZABCDEFGHI ahijklmnopqr $678
14 POINT

AJKLMNOP astuvwxy $901
18 POINT

AQRSTU azabcde $23
24 POINT

AVWX afghijk $45
30 POINT

AYZ almno $67
36 POINT

ABC apq $8
48 POINT

ADars$9
60 POINT

AEat$0
72 POINT

Example of type face FRANKLIN GOTHIC showing sizes and points.

Smaller types are called "Text Faces", larger types are "Display Faces". A typographer's job is type-setting and printing ("pulling") a limited number of printed sheets ("proofs"). The proofs, with all ordered copy printed on them, go to the artist who pastes them on his artwork for reproduction in print. Ordering of typography with all necessary indications is called "Type Specification". It is a profession in itself — specialists in this craft are sometimes called "Type Directors". They must know the names of type faces, type casting and fitting of type into definite spaces. They must also know the conventional ways of specifying type and proofreader's marks.

✕	Bad letter	⌐	Move to left
⊥	Push down space	⌐	Move to right
ꟻ	Turn over	⊓	Move up
ℓ	Take out	⊔	Move down
⋀	Insert at this point	☐	Indent one em
✓	Space evenly	¶	Make new paragraph
#	Insert space	no¶	No paragraph
⌣	Less space	wf	Wrong font
⌒	Take out all spacing	stet	Let it stand
⊙	Insert period	tr.	Transpose letter or words
ʼ/	Insert comma	Caps	Change to capitals
⊙	Insert colon	s.c.	Change to small capitals
;/	Insert semicolon	l.c.	Change to lower case
ᵛ	Insert apostrophe	ital	Change to italic
ᵛᵛ	Insert quotation	rom.	Change to roman
⁻/	Insert hyphen	b.f.	Change to bold face
ᵛ	Insert superior letter or figure	?	Query to author
⋀	Insert inferior letter or figure	○	Spell out
⊙⊙	Insert leaders	init.	Set large initial
///	Straighten lines	/–/	Insert dash

Standard Proofreader's Marks

Type faces are grouped into four categories, most of which include capitals (upper-case letters) and small letters (lower-case letters). Some type faces are also available in slanted position (*italics*).

GOTHIC or SANS-SERIF FACES. Letters in this group have stems of visually even weight (thickness) and carry no thin strokes.

ROMAN or SERIF FACES. These letters have main stems of even weight, but endings and cross-lines are thinner strokes (serifs).

SCRIPT and CURSIVES. Script letters resemble handwriting. Cursives have flowing strokes, flourishes, or fanciful curves.

SPECIAL TYPE FACES. A wide assortment of letters not fitting exactly either of the preceding groups.

GOTHIC

ROMAN

Script *Script*

SPECIAL

Type is set by the typesetter in a straight line. According to instructions, he will set letters "solid" (one next to the other, without spacing in between), or he will space them with one, two or more "points". This process is called "word letter-spacing" or "leading". Lines and words can also be set "solid" or "leaded" one, two, or more "points". Typography houses usually distribute specimen books listing type faces and their sizes to their clients.

2. TRANSFER LETTERING

This popular method allows the artist to set small pieces of copy himself. Lettering is transferred from special type sheets to paper by burnishing. This "dry transfer" process is very economical when used in projects involving "display type" for headlines in posters, booklet covers, presentation material, and film slides. Artists' supply stores give

away manufacturers' booklets listing type faces available in their Dry-Transfer Lettering Sheets. Transfer sheets can be manufactured in larger quantities following clients' designs and specifications. Besides lettering, there are transfer sheets for current architectural, drafting and charting symbols.

3. PHOTO-LETTERING

This photographic method of typesetting allows all kinds of "distortions" in conventional lettering: shortening, elongating, thickening, thinning, condensing, curving, etc. Assigned work is delivered on photographic paper.

4. "LE ROY" LETTERING

A technique of drawing letters in ink by using as a guide an assortment of acetate templates, special pens and "scribers".

5. HAND LETTERING

Artists specializing in lettering usually confine their work to letters alone. But all graphic artists, designers or cartoonists have innumerable occasions to incorporate lettering in their work. If they are familiar with lettering styles and principles, they may be able to create and design decorative headlines, trademarks and logos, or use letters in some clever animation. In book jackets, posters, packaging and promotion, a cartoonist also may become a designer by merging his skill in drawing with his own creative lettering. The field for using these combined skills is unlimited.

Study of lettering, some practice, and above all, inventiveness will expand the cartoonist's profession into the general area of designing, thus helping to open new markets for his work. Hand lettering requires knowledge of the "anatomy" of the letter and of the structure of lettered words. Conventional rules are the same as in typography, so that all creative departures, improvisations and interpretations in lettering design will be more acceptable when based on those rules.

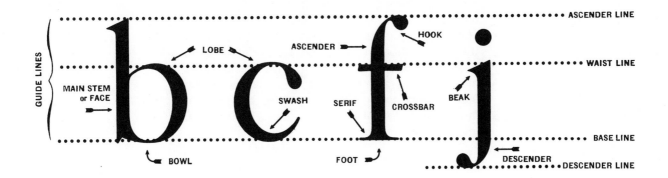

HEIGHTH. In order to make all letters forming a word in a straight line appear even, some adjustment in the heighth of the letters is necessary. By slightly extending pointed endings (upper as in A and lower as in V) and curves (as in O) between two parallel guidelines, optical illusion will make the letters appear equal in heighth.

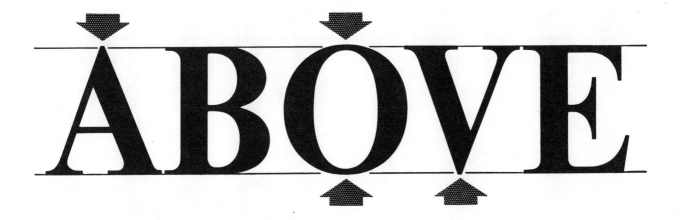

SPACING. Spacing of letters forming words should be varied so as to obtain a desired visual effect of even distribution or density (uniform "tone" or "color"). A conventional arrangement of letters will tend to avoid uneven concentration of blacks or over-extension of white spaces between the letters. Spacing between letters in a word, between words, and between lines of words, is measured in the same "points" as in sizes of type faces. Areas and distances covered by type are measured in "picas". 1 pica equals 12 points, 6 picas equal one inch.

In this word, spaces between letters vary according to the conjoint effect of two letters placed next to each other. Optically, the distribution of letters appears well balanced.

SPACING

This spacing rule of even tone is frequently disregarded to produce special or unusual effects. In the arrangement of letters, an artist will use his sense of design to obtain desired visual impressions. (See section on Logos and Trademarks.)

SPACING

Equal spaces between letters produce optically uneven effect — white "holes" and black concentrations. This uneven effect impairs readability.

SPACING

Examples of special arrangements of letters in which position and spacing of letters elude conventional rules.

SPACING
SPACING

WIDTH. The width of letters varies in accordance with the rule of optically even distribution of blacks and whites. In all alphabets, letters M and W are the widest, letter I is the narrowest. Width of all other letters varies according to their shape.

C D E F G H

I I J K L M N

O P Q R S T

U V W X Y Z

Examples of several type faces available in typography.

CENTURY BOLD ITALIC

ABCDEFGHIJKLMNOPQRSTUVWXYZ
abcdefghijklmnopqrstuvwxyz&.,:;-!?'$1234567890

STENCIL

ABCDEFGHIJKLMNOP
QRSTUVWXYZ&.,:;-!?'$

P.T. BARNUM

ABCDEFGHIJKLMNOPQRSTUVWXYZ

abcdefghijklmnopqrstuvwxyz&.,:;-!?"'$1234567890

MICROGRAMMA BOLD EXTENDED

ABCDEFGHIJKLMNOPQRSTUVWXYZ
&.,.;-!?$1234567890

HELLENIC WIDE

ABCDEFGHIJKLMNOPQRSTU
VWXYZabcdefghijklmnopqrstu

LATIN WIDE

ABCDEFGHIJKLMNOPQ
RSTUVWXYZabcdefghijkl

ENGRAVERS OLD ENGLISH

ABCDEFGHIJKLMNOPQRSTUVWXYZ
abcdefghijklmnopqrstuvwxyz&.,:;-!?'$1234567890

ROMANTIQUES

ABCDEFGHIJKLMNOPQRSTUVWXYZ
&.,.;-!?'1234567890

Decorated letters are often used to enliven typographic composition. They are used frequently at the beginning of new chapters in books and in promotion literature. These initials can be "invented" by the artist, and decorated with ornaments, flowers, figures, etc. but typographic faces may also be used and decorated by hand. The design of the initial should reflect the mood of the text.

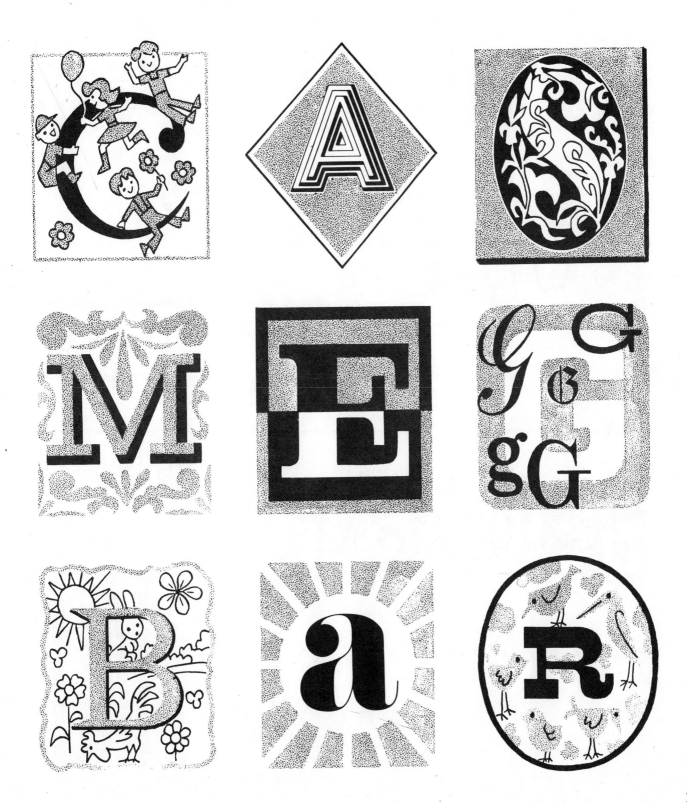

In many instances, words can be used as illustrations. There are endless opportunities to design words in such fields as posters, promotion pieces, greeting cards, window displays, signs, and book jackets. These pictorial words may merely illustrate the meaning of the word, as shown below, or suggest graphically by their style the mood of related text.

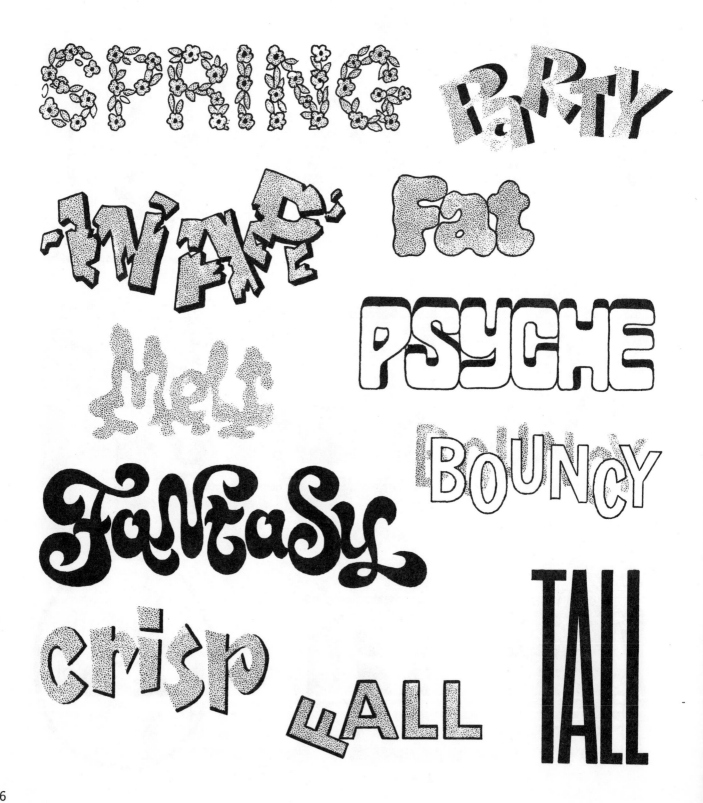

Letters and numbers are used widely in logos and trademarks which are designed as original, distinctive graphic units to be visually noticeable, aesthetically pleasing, and easy to remember.

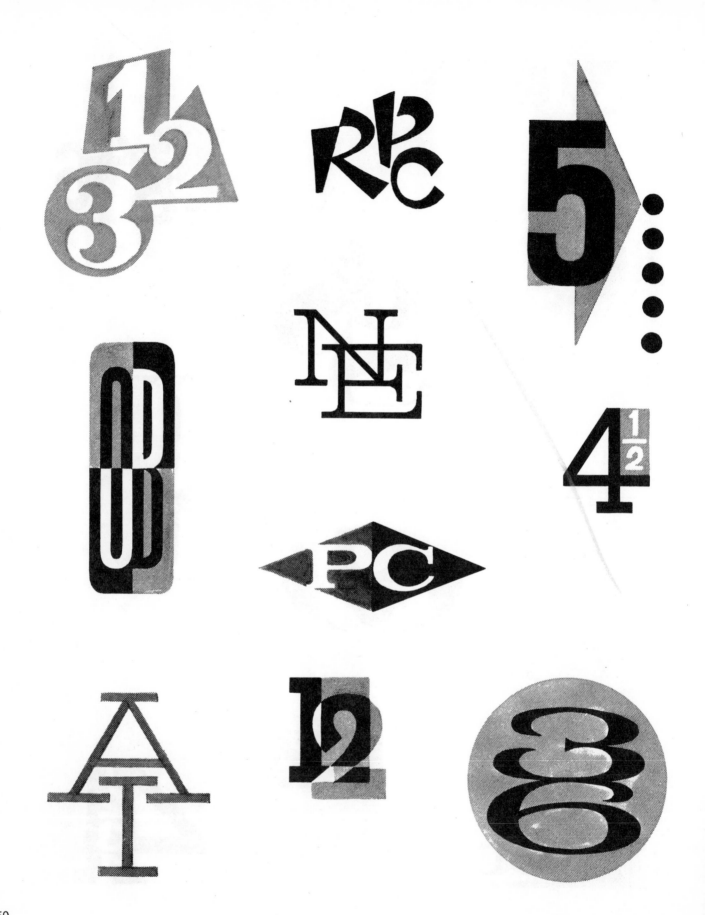

Some assignments in which I used lettering as designs.

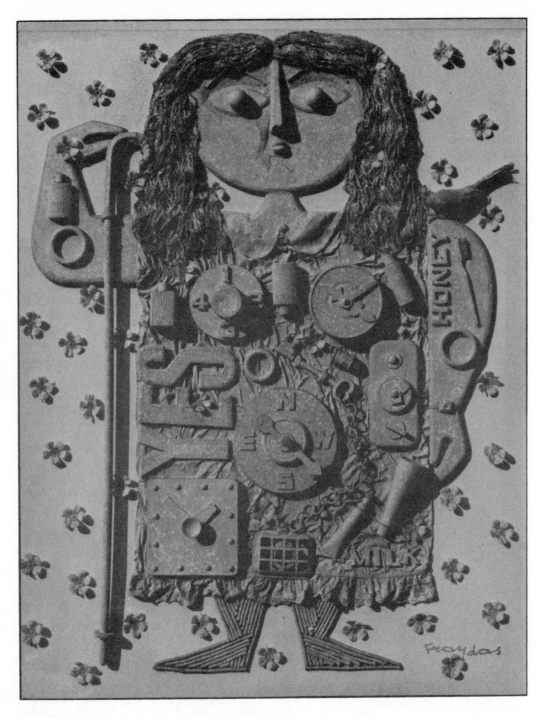

The Saint. Acrylics, wood, plastics, canvas, cord. 50" x 40". Galerie Internationale, New York.

Many fine artists include lettering in their work.
Notice the use of letters and words in my assem-
blage painting above.

THE FINE ARTS AND CARTOONING

SIMILARITY. The fine artist's basic purpose in his work is to express his own emotions, thoughts, and aesthetic reactions to life and nature. His need for communicating prompts him to display his work and to seek recognition.

However, besides having these two fundamental needs of expression and communication, artists, like other people, have practical needs—for comfortable living conditions, for security—and they have the same urge for love, companionship, and family.

The preponderance given by the artist to idealistic over practical motivations constitutes the measure of "integrity" in his work. Since absolute integrity can hardly exist, it would not be presumptuous to assert that no great work of fine art is entirely free from some "commercialism," that is, the desire for compensation. Fine painting and sculpture, therefore, are professions whose products are to be used in some practical way, either as exhibits in museums or as decorations in private homes. The final judgment on the greatness of a work of art is determined by its intrinsic aesthetic value rather than by the motives directing the artist's hand.

There are many "fine" painters who, by virtue of their purpose in their work, should be considered "practical" or "commercial" artists. On the other hand, there are "commercial" artists who, for the same reason of purpose, should be considered "idealistic."

If purity of purpose—expression and communication—is weighed against practicality—compensation and recognition—the estimation of an artist's integrity and greatness cuts across the fields of fine and commercial art.

Many a commercial artist is confronted frequently during his career by situations in which he is compelled to choose between artistic integrity and professional expediency.

DIFFERENCE. By its very nature, a painting presents itself as an independent object. This does not hold true for a work of applied art, for example, a commercial illustration.

In almost all fields to which commerical art is applied, drawings are used to sell something other than themselves. In advertising, they sell a product or a service. In publishing, they sell a magazine, a newspaper, or a book—collections of cartoons or drawings marketed as books are an exception. This difference in final purpose between fine and commercial works of art is significant, because the emotional and psychological foundations of art vary fundamentally according to this difference.

Although both types of artist may be equally concerned with the practical rewards resulting from their work, the fine artist can create undisturbed by a feeling of responsibility toward his patrons, but a commercial artist has to work with an omnipresent concern for his clients' immediate interests. This difference between fine and commercial art is reminiscent of that between the work of a music composer on the one hand, and the performance of a concert pianist on the other, or of that between the work of a writer and the performance of an actor. In a sense, the commercial artist performs in a show that must attract an audience, entertain, please, educate, or inform. Only to a limited extent can he express his individual thoughts and emotions in his work, and, unless they happen to coincide with those of his audience, they must be subjected to a process of adjustment. The commercial as well as the theatrical arts do not exist for their own sake, and, therefore, they cannot be performed without an audience.

If the fine arts are called "creative," the commercial arts can be called "performing," with the implication that the creative element contained in them is similar to that of acting.

While the work of fine art may have no function to fulfill other than that of being an object of contemplation, the work of commercial art, to be successful, must be functional.

In most cases, commercial artists do not choose the theme for their work; neither can they afford to express their personal opinions or emotions about this theme. They may, for instance, dislike or disapprove of drinking and smoking,

but, when asked to help, with their art, in the sale of liquor or cigarettes, they must be able to create a graphic eulogy for these products.

Noncommercial painters, writers, and composers can hardly be asked to create works in which they will be compelled to glorify subjects toward which they feel inimical or indifferent. HUMOR AND SATIRE. Humor used in commercial art is designed to amuse the reader or to precondition him favorably to some subsequent suggestion.

Cartoons in advertising strive to bring a smile, thus creating good will on the part of prospective customers. Syndicated continuities stimulate readers to purchase the same newspaper daily. Gag cartoons interspersed throughout a magazine make readers flip the pages and see all the advertisements. Children's book illustrations must amuse youngsters in order to convey, in an enjoyable manner, some educational or behavioral ideas. Even political cartoons with satirical content must, in their spirit, reflect the political and social convictions of their newspaper's audience and follow the newspaper's editorial policy.

Since some practical purpose is invariably contained in all cartoons used commercially, the humorous tenor of these cartoons must be sympathetic to the readers, cheerful, and in any case, nonoffensive.

In the fine arts, humor can be an uninhibited expression of the artist's personality and a reflection of his emotions and individual views. Instead of being merely entertaining or expedient, humor in fine art may contain sarcasm, and it may deal with all problems without flattering any particular group of viewers. In the work of Picasso, Klee, Rouault, Miro, Shahn, and Grosz, satirical humor expresses the individual philosophy of the artist. Their sarcasm derives from a desire to improve and correct what they feel is wrong with their society as a whole or with some individuals in it. These artists' expression of resentment and criticism should be construed as a symptom of their longing for a better world.

Design concepts, techniques, and moods displayed in the works reproduced herewith inspired many a cartoonist and designer of today. Through some enigmatic correlation of emotional, psychological, and physiological faculties, outstanding artists seem to possess simultaneously the qualities of humanity, intelligence, and superior dexterity.

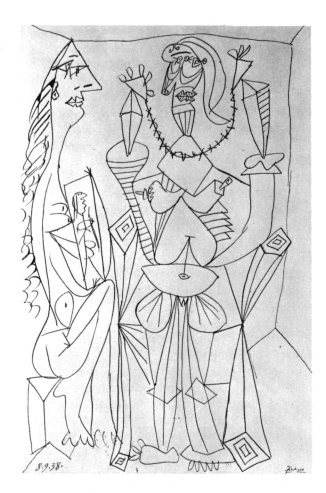

PABLO PICASSO. The Necklace. 1938, pen and ink, 26¾ x 17⅝". The Museum of Modern Art, New York. Acquired through the Lillie P. Bliss Bequest.

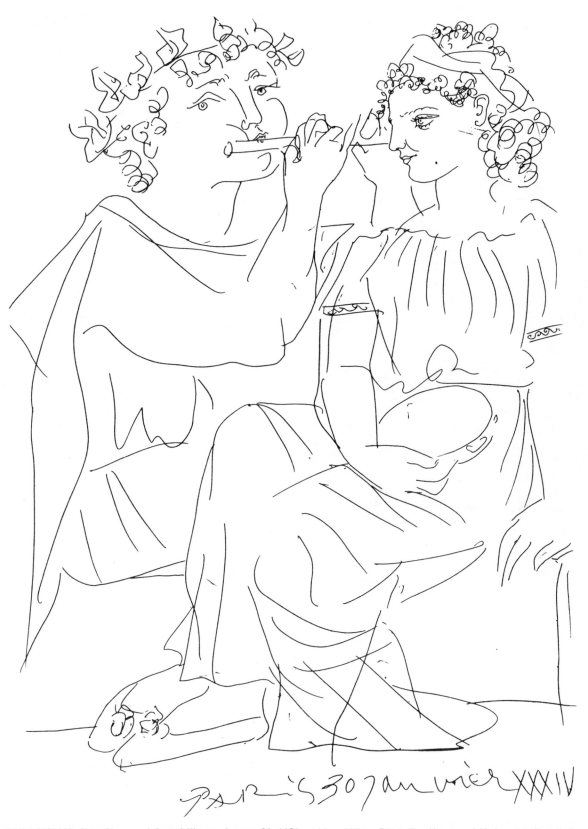

PABLO PICASSO. Flute Player and Seated Woman. January 30, 1934, etching, 10$\frac{15}{16}$ x 7$\frac{13}{16}$". The Museum of Modern Art, New York.

PAUL KLEE. In The Spirit of Hoffman. 1921, lithograph, 11⅜ x 8¾".
The Museum of Modern Art, New York.

GEORGES ROUAULT. We Think Ourselves Kings. 1923, aquatint and
drypoint over heliogravure, 24 x 17¹⁄₁₆". The Museum of Modern Art,
New York. Gift of Victor S. Riesenfeld.

PAUL KLEE. Suicide on The Bridge. 1913, lithograph, 7¼ x 5¼".
The Museum of Modern Art, New York. Gift of Victor S. Riesenfeld.

BEN SHAHN. Dr. J. Robert Oppenheimer. 1954, brush and ink, 19½ x 12¼". The Museum of Modern Art, New York. Gift of the Artist.

BEN SHAHN. A Good Man is Hard to Find. 1948, gouache, 96 x 62". The Museum of Modern Art, New York. Gift of the Artist.

GEORGE GROSZ. Fit for Active Service. 1918, pen and ink, 14⅝ x 13⅜". The Museum of Modern Art, New York. A. Conger Goodyear Fund.

JOAN MIRO. Portrait of A Lady in 1820. 1929, oil on canvas, 45¾ x 35⅛". The Museum of Modern Art, New York.

Reproduced below are examples of satirical cartoons by three of the most celebrated cartoonists of the past: Honoré Daumier (French, 1808–1879), Thomas Nast (American, 1840–1902), and Caran d'Ache (French, 1858–1909). These cartoonists achieved the stature of fine artists, not merely because of their talent and craftsmanship, but also because the spirit of their satirical art had defied the conformity of humor in their times (Daumier was a painter as well as cartoonist).

Undoubtedly, there are present-day cartoonists whose work may be compared in importance with the work of their illustrious predecessors, but their greatness can be ascertained only in the future, when their work will be judged in the perspective of time.

Drawing by HONORÉ DAUMIER. Courtesy The New York Public Library.

LA COURSE PARIS-BERLIN ou L'ESPRIT NOUVEAU

Drawing by CARAN D'ACHE. From "Pages d'Histoire." Courtesy The New York Public Library.

LANDING OF COLUMBUS, OCTOBER 12th, 1492.

Drawing by THOMAS NAST. From "Nast's Illustrated Almanac," October 1871. Courtesy The New York Public Library.

MODERN ART. Social, scientific, and technological changes in our world have brought new forms of expression.

Modern art is a visual language of artists in their times; it represents their emotional, intellectual, and aesthetic responses to new conditions of life. Whereas the language of the past remains an element contributory to our culture, the language of the present becomes a functional part of our lives today.

As the new ways of living and thinking find their reflection in new forms, new styles, and new aesthetic concepts in art, art conversely influences and contributes to changes in modern living.

Through its applications in the fields of industry, advertising, and publishing, modern art has become a part of everyone's daily life.

Many people who profess suspicion about the merits and validity of modern art do not realize that they have already absorbed it with delight in their surroundings. They respond to advertising inspired by modern art. They buy homes, furniture and furnishings, cars, clothes, books, and appliances all designed according to the new concepts in art.

It is an intriguing phenomenon that even some commercial artists whose work reflects a direct influence of modern painters lack awareness of what are the fundamental sources from which the style of their work derives.

Commercial artists are required to be sensitive to changes occurring in their times and to respond to these changes in their work. It would, therefore, be highly beneficial to professional cartoonists to become interested in the study of modern art. In preserving this interest throughout their careers, commercial artists may keep abreast of changing trends, thus avoiding the unhappy predicament of becoming dated in style.